Prestel Museum Guides

Hamburger K...
Contemporar...

KT-175-548

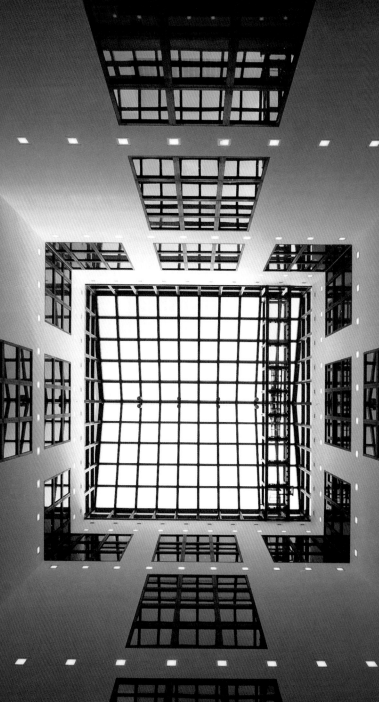

Prestel Museum Guides

Hamburger Kunsthalle
Contemporary Art Wing

Prestel

Munich · New York

Hamburger Kunsthalle
Contemporary Art Wing
Glockengiesserwall
D-20095 Hamburg
immediately opposite the main station
tel.: +49 40 2486 2612
fax: +49 40 2486 2482
Internet: http:/www.hamburg.de/Behoerden/Museum/kh/
e-mail: Kh@Kulturbehoerde.hamburg.de

Opening times
Daily except Monday 10 a.m. to 6 p.m.
Thursday to 9 p.m.

Museum service
Information on guided tours, schools discussions, painting courses, holiday
programmes on tel.: + 49 40 2486 3180

Public guided tours
Sunday 11 a.m.
Wednesday 12 noon
Thursday 7 p.m.
short tours daily in the 'Im Blick' (In Focus) series
KopfHörer - acoustic guide to the gallery

Library
Tuesday to Saturday 11 a.m. to 5 p.m.
Presentation of drawings and printed graphics in the Kupferstichkabinett :
Tuesday, Thursday, Friday 2 to 5 p.m.

Audio and video programmes
A selection of artists' videos is played in the Videopavillon. About 100 items from
the audio collection can also be heard there.

Expert advice
On paintings, drawings and printed graphics
Wednesday 2 to 4 p.m.

Café Liebermann
In the historic columned hall
daily except Monday 10 a.m. to 5 p.m.
Thursday to 8 p.m.

Bistro
In the Contemporary Art Wing
daily 10 a.m. to 1 a.m.

Underground car park
Under the Contemporary Art Wing, Ferdinandstor entrance

If you are likely to visit the Hamburger Kunsthalle on a regular basis we suggest
that you join the friends' society: 'Freunde der Kunsthalle'. You can get
information about the many advantages of membership from:

Freunde der Kunsthalle e.V.
Glockengiesserwall
D-20095 Hamburg
tel.: +49 40 335 244
fax: +49 40 3039 9976

Contents

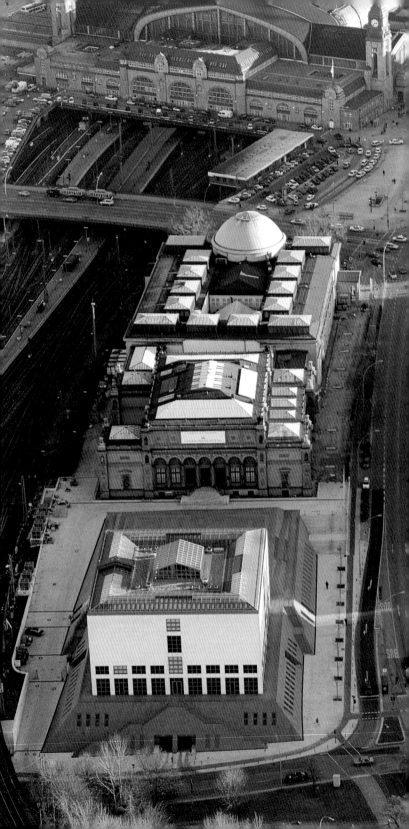

A Link
with the Present

The Hamburger Kunsthalle's new building forms a new link with the present. The Kunsthalle was equally interested in the past and the present even under its first director, Alfred Lichtwark, and now the contemporary world has a showcase in a new building. The Contemporary Art Wing is an extension for the Kunsthalle, and a new department as well. In the old building visitors move from medieval art via the 19th century and Classical Modernism to the 1950s, when the panel painting was still holding its own, although some artists – Manzoni, Fontana, Yves Klein – had already started to question it. The new building shows the many ways in which art has developed since about 1960.

The building

The new building was designed by architect Oswald Mathias Ungers, and it complements the earlier buildings, dating from 1869 (Hermann von der Hude and Georg Theodor Schirrmacher) and 1919 (Albert Erbe) in a unique fashion. Hitherto the Kunsthalle had just been an appendage to the main station in the urban scene, but it is now completely independent. The gleaming cube is perfectly placed to complete the panoramas on the Inner and Outer Alster lakes, and at the same time provides a striking conclusion for the 'Art Mile' between the Elbe and Alster rivers.

The building was commissioned by the Hamburg parliament in early 1992, work began in the same year and was largely complete by summer 1996. Federal President Roman Herzog opened the Contemporary Art Wing on 23 February 1997.

The building has 5,600 square metres of exhibition space, and is simple to the point of austerity. Its exterior forms a clear contrast with the lavishly articulated façade of the old Kunsthalle, whose effect is particularly enhanced by the new building's clearly distinct underground base storey with a cube towering out of it. Ungers' architectural principles can be identified most clearly in the impressive light well. The architect has made the actual exhibition rooms rather more reticent, to create space in which the works of art can achieve their maximum impact.

The square is the perfect form for Ungers, on the basis of the Renaissance, Palladio and Ledoux. For his museum concept he consciously draws on Karl Friedrich Schinkel in particular.

◁ Aerial photograph of the Hamburger Kunsthalle

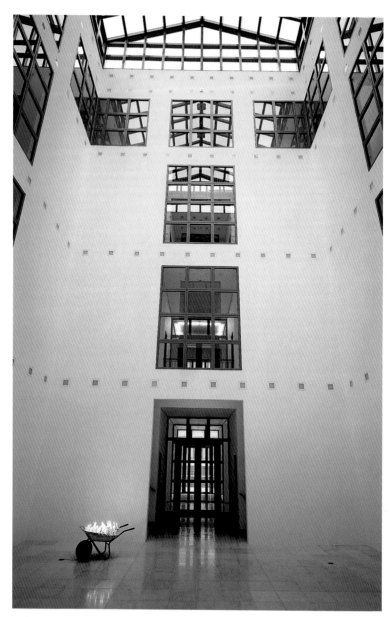

Light well in the Contemporary Art Wing with 'Arbeiten im Reichtum III' (Works in Wealth III), 1983/96, by Stephan Huber

We agreed on a few principles for this museum building at the very beginning of our work together, and we hope that it expresses them lucidly: the best possible conditions for art; no ostentation in the architecture; a rhythmic succession of flexible spaces; simple materials.

Recent art history

Our aim in the Contemporary Art Wing is to reveal coherent connections, rather than simply to present individual works. We have made an ambitious attempt to show key international developments and the most significant positions adopted by artists in recent decades, in other words to give an overall view of the very large range of activity, and thus present recent art history as vividly as possible.

Our starting point in the Contemporary Art Wing is the second great upheaval – after abstraction in about 1910 – in 20th century art, the "Ausstieg aus dem Bild" (departure from the picture; Laszlo Glozer), sometimes referred to as the "death of painting". Pop Art turned to the everyday world, the streets, to civilization; Arte Povera, Europe's critical response to Pop Art, went back to simple materials and archaic techniques. The first results of the "death of painting" were new forms of object sculpture and an alien material language. Anyone – like Gerhard Richter or Sigmar Polke – who continued to paint in the sixties usually did so as a conscious reaction to this "death": they were painting after the end of painting.

We present significant developments from 1960 down to the present day. Of course we cannot follow all the latest movements, and we would not wish to either, but wherever clear outlines are beginning to show – as in art by today's forty-year-olds in Germany and America – we draft an image of events that is bound to change from time to time: the Contemporary Art Wing intends to keep on the move itself.

We have adopted the Kunsthalle's usual in-house approach to presenting art: large complexes of work by important artists ('artists' rooms') alternate with an overview of the many facets of different movements. This should reveal the radical quality of subjective approaches and also bring out typical aspects of a period, making it possible for viewers to compare, understand, evaluate and form judgements: Warhol and Oldenburg against a background of American Pop Art, Joseph Beuys in the context of spiritualizing 'poor' materials, Richard Serra using the direct formal language of materials, Hanne Darboven as the central personality in Concept Art, Bruce Nauman as a reference point for recent American art.

The collectors' role

Following the tradition of Hamburg and its northern neighbours, we have worked particularly closely with private collectors. However, the Contemporary Art Wing does not show collections. We were principally concerned to put an art-historical concept into practice. But despite numerous important purchases in recent years, and despite very considerable donations and gifts, our own resources were not sufficient for this. The Contemporary Art Wing has acquired individual works, large complexes of works and complete collections on the basis of our art-historical concept, often as long-term loans for a period of ten years.

Particular mention should be made of the Berlin Onnasch Collection, which includes outstanding Abstract Expressionists and American Pop Art, a Munich Collection, which has a large range of works by Beuys, some of them early, a Hamburg Minimal Art Collection, the Hamburg Collection of E. and G. Sohst, including Concept Art (and paintings by Gerhard Richter and Sigmar Polke), the Düsseldorf Cremer Collection from the field of Fluxus and the Nouveaux Réalistes, the Stuttgart Froehlich Collection, including

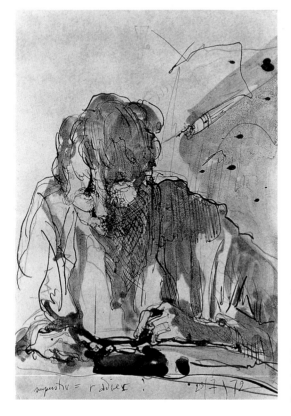

Horst Janssen, self-portrait 'Imperativ: radier!' (Imperative: etch!), 1972, wash and pen-and-ink drawing. Gerhard Schack Collection in the Hamburger Kunsthalle

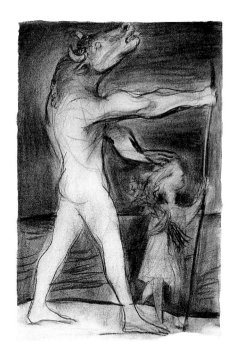

Pablo Picasso, 'The blind Minotaur led by a little girl', 1934, charcoal on paper. Hegewisch Collection in the Hamburger Kunsthalle

selected works by Polke and Nauman, the Stuttgart Scharpff Collection, which consists of a complete group of works by young American artists.

Two outstanding Hamburg collections shown in small graphics galleries mark the transition from the old to the new building, from tradition to the contemporary world: the Gerhard Schack Collection, including sheets by Horst Janssen and the Hegewisch Collection, including Classical Modern drawings and graphics.

The artists' contribution

We have tried to co-operate with artists wherever possible. About 25 of them were in Hamburg in the second half of 1996 or early 1997 to deal with the arrangement or staging of their work; they included Claes Oldenburg, Georg Baselitz, Sigmar Polke, F. E. Walther, Hanne Darboven, Reiner Ruthenbeck, Stephan von Huene, Thomas Schütte, Olaf Metzel, Andreas Slominski. They themselves often filled in gaps which became apparent in the process. Our intention was to show each artistic project to its best advantage, succinctly and authentically.

We asked some artists to add new works to those that were already in the Kunsthalle, to produce a new group that was complete in itself (F. E. Walther, Reiner Ruthenbeck) or a small, well-

Entrance hall with Bogomir Ecker's 'Tropfsteinmaschine' (Dripstone Machine) biotope, 1996

arranged retrospective (Thomas Ruff). We conducted long and detailed discussions with Georg Baselitz, and also with Gerhard Richter, Sigmar Polke and Jannis Kounellis about their ensembles.

As well as this, we were able to persuade some artists to design a piece specially for the Contemporary Art Wing and to realize it as a permanent installation: commissioned work. Thus in places it was possible to achieve the unity of space and work that artists generally hope to achieve today. Jenny Holzer gave the point of transition from the old to the new building a shape of its own; Ian Hamilton Finlay made the area in front of the museum into a work of art; Ilya Kabakov designed two rooms for symbolic art therapy; Jannis Kounellis installed a massive set of layered sacks full of stones; Richard Serra created a permanent 'Splashing' work and an equally permanent wall drawing on the spot; Rosemarie Trockel designed a complex work for a prescribed spatial situation. To say nothing of Bogomir Ecker's 'Tropfsteinmaschine' (Dripstone Machine), which is an integral part of the building that was realized as part of Hamburg's 'Art in Public Places' programme.

Incidentally there are (still) complete, firmly anchored works of this kind in the old building: Rebecca Horn's 'Chor der Heuschrecken' (Grasshoppers' Chorus) in the roof-space, Anna Oppermann's 'Ensembles' in the small galleries in Glockengießerwall, Gerhard Merz's design for the stairwell in the entrance. In every case the artists' involvement has created a particularly close link with the space or the architecture; they are evidence of art's dream of escaping from the freely available individual work and finding permanent and authentic places.

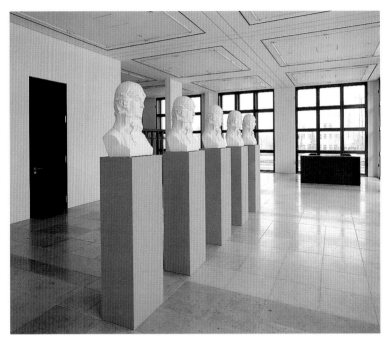

*Entrance hall with 'Saint-Just: Äußerungen' (Saint-Just: Remarks), 1991–94,
by Ian Hamilton Finlay and Annet Stirling*

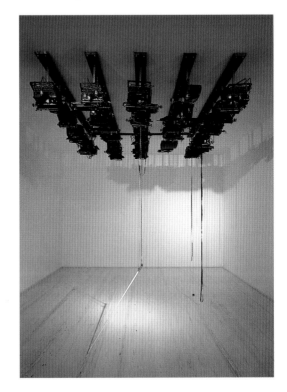

*Rebecca Horn, 'Chor
der Heuschrecken I'
(Grasshoppers'
Chorus I), 1991*

The old building in terms of the new one

We started to rearrange the old Kunsthalle in good time, in the early nineties. We wanted it to hold its own when the anticipated new building appeared: all the galleries were renovated and the collection was rehung. This new hanging of the Old and Modern Masters – from Meister Bertram to Arnold Böcklin – was opened to the public in 1993. Shortly before Ungers' building was opened the collection of twenties painting was also presented in a new way – with the accent on two galleries devoted to single artists: Wilhelm Lehmbruck and Max Beckmann.

Thanks to the help of a whole series of Hamburg patrons, restoration of the 1870s staircase in the old Kunsthalle was largely completed in 1995. This changed the status of the adjacent Makartsaal, and this shift was further emphasized when we rethought the room in 1996: the historic Makart between his exact opposites, the French and Scandinavian Moderns.

This conflict was taken up again on the ground floor of the old building when we set up a Historicist gallery in early 1997, juxtaposed with galleries containing pictures by Liebermann, Corinth and Slevogt. The whole wealth of tension in 19th century painting is now substantially clearer than it used to be: something we need for a more thorough understanding of 20th century art.

Thanks

We had to reach the international standard demanded by the Kunsthalle's classical stock, by Ungers' challengingly ambitious building, and generally by a new building in a cosmopolitan city that is necessarily in competition with other cities, and we had only a few years in which to do it. Where resources were not adequate, we were able to find effective support from outside.

The ever-beneficent Stiftung zur Förderung der Hamburgischen Kunstsammlungen (Foundation for the Promotion of Hamburg Art Collections) has acquired a whole series of important works for the Contemporary Art Wing in recent years (Baselitz, Boltanski, Kounellis, Richter). The 'Freunde der Kunsthalle' gave us Jenny Holzer's installation and two large paintings by Georg Baselitz to mark the opening. The Otto Versand company helped us to purchase two early, multi-partite works by F. E. Walther. The Hypo-Bank gave us two objects by Klaus Kumrow. F. E. Walther and Cady Noland each presented us with one of their works. The new F. u. W. Stiftung für zeitgenössische Kunst in der Hamburger Kunsthalle acquired works by Andreas Slominski and Bernhard Prinz. I should like to take this opportunity to offer my most sincere thanks to everybody who has contributed in this way to the high quality of the new collection.

But I should also like to thank the authors in the Kunsthalle and those responsible at Prestel Verlag for showing such commitment and working so fast: this made it possible for this museum guide, which in every respect reflects the precise state of the presentation at the time the building was opened, to appear so soon after the Contemporary Art Wing was completed. My special thanks go to Christoph Heinrich and Ortrud Westheider, who conceived this volume so expertly and energetically and realized it so responsibly.

Uwe M. Schneede

Jenny Holzer's installation 'Ceiling Snake', 1996, at the point of transition from the old building to the Contemporary Art Wing ▷

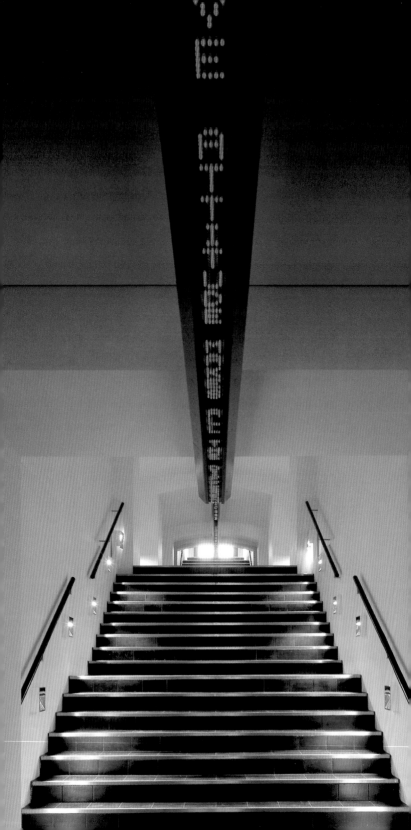

The Works

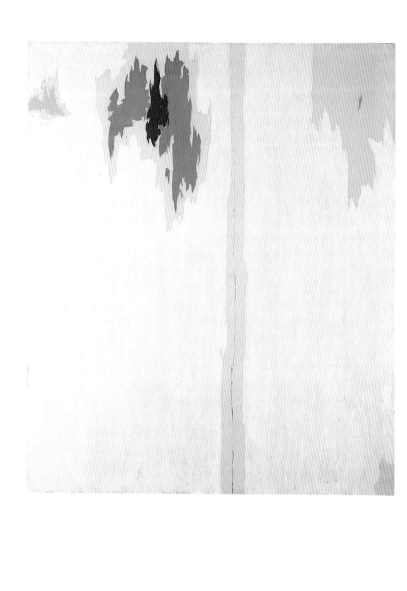

Abstract Expressionism

The first American avant-garde art dates from the forties. It is called 'Abstract Expressionism' after early twentieth century European Expressionism, but its colours acquire a life of their own that would have been alien to Expressionism. Gigantic formats offer coloured spaces into which the viewer can plunge.

The artists no longer see their pictures as compositions that always strive for harmony and balance, but perceive them as a field that can be continued beyond its boundaries. Every point is equally important in these works, and offers access to the picture. The painters wanted to design their pictures on an enormous scale, so that they were impossible to grasp at first glance, not open to assimilation. The Second World War had shaken American artists as well as their European colleagues. Reports about people being persecuted and cities destroyed made many people start to lose faith in humanist ideas. A conviction arose among the Abstract Expressionists, in parallel with Existentialist philosophy, that each human being was responsible for his or her own fate and had to keep designing it afresh. The painters translated their views into pictorial creations that allow the viewer this freedom.

◁ **Clyfford Still** 1904-1980
Untitled 1953
Oil on canvas
276.9 x 233.7 cm
Reinhard Onnasch Collection in the
Hamburger Kunsthalle

It is the longitudinal axis that renders Clyfford Still's pictures unlike landscapes. They do not have a horizon, but a vertical corresponding to the posture of a human being. This means that the colour design affects perception directly, not just in terms of seeing, but in terms of the whole body. When confronted with these large formats, viewers start looking for a way of finding their bearings. The patches of colour are frayed at the edges. They do not have definite borders. The untreated canvas shows through in a number of places. The eye travels over the surface of the picture and wanders to and fro between the dense colour relief and the transparent zones. Still's pictures have often been compared with landscapes. The artist himself rejected this interpretation by pointing out that he had painted only pictures about himself. He also rejected the landscape as a model for romantic retreat – his work is about human beings as living entities. OW

Barnett Newman 1905–1970
Uriel 1955
Oil on canvas 243.8 x 548.6 cm
Reinhard Onnasch Collection in the
Hamburger Kunsthalle

'Uriel' is the name for the bringer
of light in Jewish culture. Barnett
Newman's enormous picture over-
whelms us with colour. Here
colour is the actual event. Until
this point painting had been driven
by form. Colour was subordinated
to form: blue as the colour of the
sky, brown as the colour of the
earth and so on. That is no longer
possible in Newman's pictures.
Turquoise blue rubs shoulders with
reddish brown. It is no longer pos-
sible to find one's bearings in the
picture in terms of top and bot-
tom. The colours are separated by
vertical lines, the so-called 'zips'.
Colour is not used to characterize
an object here, and it no longer
has any symbolic function either,

which means that it can make an
absolutely direct impact on view-
ers. But nothing pre-defined: the
turquoise does not have to be
seen as the depths of the sea. Feel-
ings are invoked that are strongly
dependent on the situation and
determined by the way in which
the colour is experienced. OW

Franz Kline 1910–1962
Zinc Door 1961
Oil on canvas 235 x 172 cm
Reinhard Onnasch Collection in the
Hamburger Kunsthalle

It is possible to make out a win-
dow in Franz Kline's 'Zinc Door'. It
is impossible to decide whether
the window is opening or closing.
This fits in with Kline's tireless
examination of the colours black
and white, which he constantly
wanted to keep in a state of ten-
sion. Black was never to be an

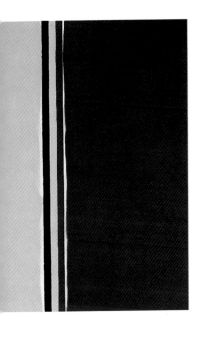

opening, an illusion of depth, and white was never to be perceived as closed pictorial ground. Franz Kline's early works were pictures of big cities: the lettering, advertisements and traffic signs in the modern city inspired him to paint the black-and-white pictures. Franz Kline is the only Abstract Expressionist exhibited for whom producing a representation of reality is still important, even though he then restricts himself to black and white, thus negating it again. OW

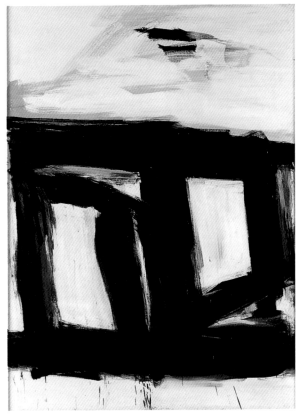

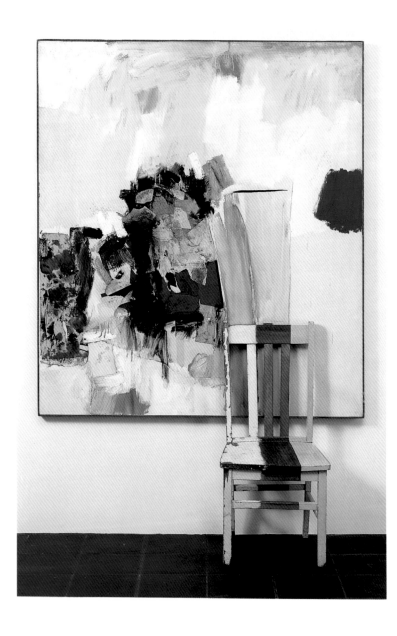

Pop Art

Pop is not a definition of a style, it is the roof under which a number of very different sixties cultural phenomena are collected. The idea of Pop Art, used for the first time by the English critic Lawrence Alloway in 1954, unites an onomatopoeic word for an explosion with the abbreviation for popular. This art was loud and brightly coloured in its motifs and resources, and popular in its aims: Pop Art was the new art of the people.

Abstract Expressionist painting set the international tone well into the sixties; a new generation of artists found its tone too subjective, too elitist and unduly out of touch with reality. Work by New Yorkers Warhol, Wesselmann and Oldenburg and the English Pop Artists Hockney and Jones was intended to find a place in art for the reality of modern media society: advertisements, television, comics and films were the driving force behind everyday Western life and provided a stock of images that was familiar to everyone. The individual artists had very different attitudes to the achievements of the consumer society: they celebrated them wholeheartedly, toyed with them coolly and ironically or attacked them with biting satire.

High culture and subculture, museum and show business, come together in Pop Art. These works reflect a new image of men and women, defined in terms of their appearance, ideas and behaviour by advertising and the media, and who turned into consumer items themselves when they became stars. CH

◁ **Robert Rauschenberg** b. 1925
Pilgrim 1960
Oil on canvas, collage elements
in fabric and paper, varnish
on chair, metal hinge
200 x 143 x 45 cm
Reinhard Onnasch Collection in the
Hamburger Kunsthalle

Robert Rauschenberg's 'Pilgrim' is a key work in terms of the "death of painting". This painting still starts as Abstract Expressionism, but the addition of the chair shows the beginnings of a new art of the object, in which banality and ordinariness take over from the sub- lime quality that characterized Abstract Expressionism. This new beginning for art is underlined by Rauschenberg's title: 'Pilgrim' is an ironic reference here to the conquest of America by the Pilgrim Fathers – a new kind of art is established by capturing new territory. This collage or *assemblage* is no longer perceived polemically as a subversive technique, as in the work of Kurt Schwitters, but as an integrative method that combines the familiar with the alien. For this, Rauschenberg coined the term 'Combine Painting'.

MS

the traditional sense. He said: "I'm used to regarding mass produced things in a more relaxed way When I concern myself with these products in my work it's only to find out where I can get a new way to present my art." MS

Larry Rivers b. 1922
Ford 1961
Oil on canvas 152.3 x 135.8 cm
Reinhard Onnasch Collection in the
Hamburger Kunsthalle

The gestural painting in Larry Rivers' 'Ford' is still committed to Abstract Expressionism, but the name of the make of car, obviously stencilled and entirely legible, is in striking contrast with this. It can be compared with other mass-produced items that crop up in art at the same time.

But while Andy Warhol, for example, introduced series of advertising images as mass-produced goods into art in order to disempower the individual image, Rivers was more concerned with artistic variation in

Claes Oldenburg b. 1929
Sewing Machine 1961
Wire, plaster, enamel paint
115 x 158 cm
Reinhard Onnasch Collection in the
Hamburger Kunsthalle

Familiar commercial goods – groceries, clothes or an old-fashioned sewing machine – have their own life breathed into them by Claes Oldenburg's work, becoming shiny, squashy, coarse and brightly colourful. The paint is applied in

several layers and seems to be trying to detach itself from the abstract surface and to find some possibility in this trivial three-dimensional thing that will allow it to feel its way out into the surrounding space. Object and background combined in the creased and crumpled surface – nevertheless shining as though it has just been painted – of the muslin strips, soaked in plaster and thickly enamelled and then shaped on a wire frame to form this colourful object.

Oldenburg offered works from his 'The Store' series for sale in a real shop for a time, and provided fresh supplies on the spot like a butcher or a baker: art that pushes its way into the street.

CH

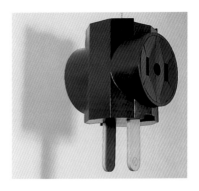

practices. In this way he set a memorial to the modern American way of life in a large number of public works, always with a hefty pinch of irony.

MS

Claes Oldenburg
Three-Way Plug, Model 1969
Wood, masonite
149.9 x 99 x 72.4 cm
Reinhard Onnasch Collection in the
Hamburger Kunsthalle

The addition of the word 'Model' to the title in the three way plug shown here identifies Claes Oldenburg's practice of monumentalizing everyday things and thus surprising viewers in museums and in public places alike: for example, he placed his 'Giant Three-Way Plug' as an enormous steel and bronze structure outside the Saint Louis Art Museum.

Oldenburg's change of scale, his immense enlargement of objects and changes of material – substituting something quite alien to the object for the usual material – links him to the Surrealists' pictorial

Andy Warhol 1928–1987
Dance Diagram – Foxtrot 1962
Acrylic on canvas 183 x 137 cm
Reinhard Onnasch Collection in the
Hamburger Kunsthalle

Warhol's dance diagram is a set of instructions of the kind that could be found in any sixties dancing manual. It suggests that anyone can learn to dance elegantly if they

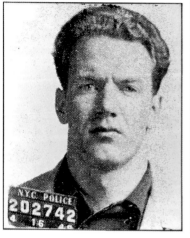

simply stick closely to the numbered scheme. The United States was inundated with these instructions at the time: how to do various hobbies, how to bear children, how to be more beautiful and more successful. Warhol presented a central idea from the American mainstream boldly and simply: the idea that there were rules for everything and the hope that everything is possible and can be achieved if one keeps precisely to these rules.

Warhol presented this painting on a rostrum in his early exhibitions. This made the functional diagram into an object that was both an image that could be looked at from all sides and also a life-size representation of dancing instructions. CH

Andy Warhol
Most Wanted Men No 6,
Thomas Francis C. 1964
2 parts, screen print on canvas
each 122 x 99 cm
Reinhard Onnasch Collection in the
Hamburger Kunsthalle

Andy Warhol was obsessed with the star cult: in 1964 he included the 'Thirteen Most Wanted Men' in his gallery of pop stars, alongside Marilyn Monroe, Jackie Kennedy and Elvis Presley. Warhol based his pictures on photographs that were already familiar and, where possible, had already been reproduced en masse. The 'Most Wanted Men' series used wanted posters of the kind that could be found at every bus-stop in the USA at that time. The picture is so heavily enlarged that the grain on the cheap photograph becomes an alienating graphic surface, and it is so closely cropped at the borders that the face acquires a monumental quality.
This is the way in which idols are presented, but who models himself on criminals? Warhol substitutes

media presence for the criterion of morality. Thomas Francis C. is a mask that exudes both a threatening quality and passion, violence and sex appeal, in brief: a star. CH

Andy Warhol
Twelve Jackies 1965
12 parts, synthetic polymer, screen print on canvas 204.5 x 122.5 cm
Reinhard Onnasch Collection in the Hamburger Kunsthalle

Twelve panels of equal size show a portrait of Jacqueline Kennedy, the widow of John F. Kennedy, the President of the United States who was assassinated in 1963. It is based on a photograph taken at Kennedy's funeral and distributed at the time by the mass media.

By using the silk screen process to duplicate the image and thus rendering it anonymous, Warhol created distance from the viewer, but also deliberately and emphatically drew attention to the process by which the original image is eroded. The screen printing technique, which Warhol had discovered for himself just previously, supports this underlying concept of the work: the same printing screen is always used, but variations occur owing to different printing pressures and the effect of using up the ink.

By repeating the motif several times, Warhol successfully manages to arrest a historical moment, as if a film had broken: the image becomes part of the collective memory. MS

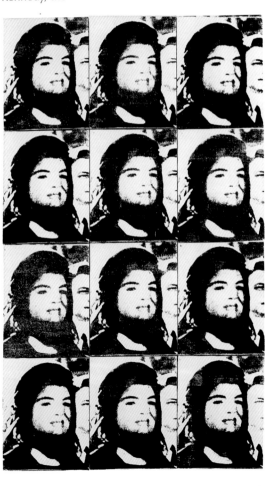

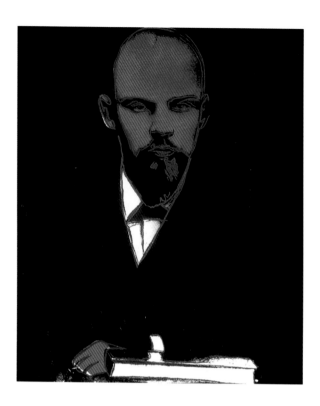

Andy Warhol
Lenin 1986
Acrylic and screen print on canvas
213 x 178 cm
Klüser Collection in the Hamburger
Kunsthalle

This large-format portrait, one of
Warhol's last pictures, is based on
a small black-and-white photo-
graph of the young Lenin copied
from an 1897 group photograph
and retouched for official use.

'Lenin' differs from the early por-
traits in its reduced, though strong,
colouring, which has been applied
to the screen print in a separate
process. Lenin's body and the sur-
rounding space merge into an
even, dark area in the picture's
black ground. Only the whiteness
of the shirt and books, and the
glowing colours on the figure's
head and hand stand out from the
black. The hooded eyes, which are
imbued with suggestive force, are
the centre of attention. The way in
which the figure emerges from the
darkness is like a dramatic act:
awareness of power acquires a
body.

MS

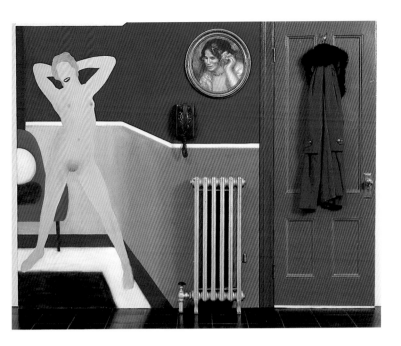

Tom Wesselmann b. 1931
Great American Nude No 44
1963
Various materials 206 x 268 x 22 cm
Reinhard Onnasch Collection in the
Hamburger Kunsthalle

A fleeting glance suggests advertising – for the physical well-being induced by the pleasant achievements of Western civilization: heating, telephone and decorative art à la Renoir.

But a second glance is somewhat alarming: everything is more real that the human being, who is in fact represented by a transfer.

The woman does not have a face, as usual in Tom Wesselmann's 'Great American Nudes' series. The artist absolutely refused to give the nudes individual faces because he was concerned with the satirical contrast between people and things. The aggressive eroticism formulated in the proffered pose pales into insignificance in the presence of the objects. The title sounds ambitious but is at the same time condescendingly patronizing in tone. It relates a broad range of American goals: the Great American Dream or the Great American Novel. MS

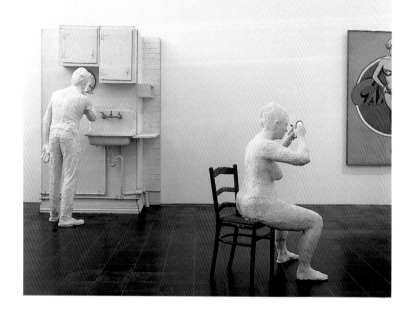

George Segal b. 1924
Artist in his Loft 1969
Plaster, wood, metal, glass, porcelain
225 x 175 x 150 cm
Reinhard Onnasch Collection in the
Hamburger Kunsthalle

Girl Putting on Mascara 1968
Plaster, stage properties
142.5 x 102 x 81 cm
Hamburger Kunsthalle

These are snapshots of everyday activities that George Segal has alienated in his sculptures: he combines everyday *objets trouvés* with the unreal whiteness of the plaster body. The artist came closer to his declared aim of fusing the representational and the abstract in 1961, when he discovered this plastering technique from newly developed bandaging for broken bones.

Segal's art takes its scale from life and yet is not realistic. His figures are portraits, but specific facial features are missing. Human behaviour, rather than individual qualities, is central to his work: he is interested in what is typical. His sculptures are derived directly from everyday human existence. Segal affirms life as it is: he is a 20th century genre artist.

MS

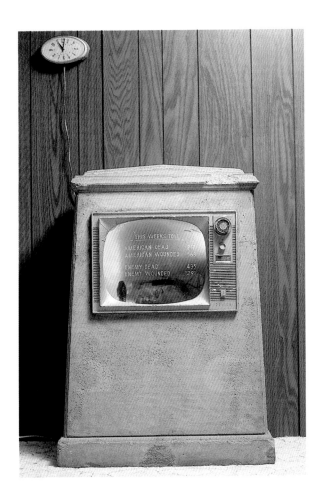

Edward Kienholz 1927–1994
The Eleventh Hour Final 1968
Room installation (detail)
Reinhard Onnasch Collection in the
Hamburger Kunsthalle

In 1968 Edward Kienholz built a
little room and furnished it as a
living-room with couch, table and
television set. The furniture ar-
rangement makes it immediately
obvious that the room in intended
for one activity only: watching
television. But Kienholz has cast
the television cabinet in concrete,
and thus transformed it into a
tombstone. The screen shows a
dummy head and lists of the dead
and wounded.

This Environment is a comment
on the Vietnam War and at the
same time addresses television as
a medium critically. The 'Eleventh
Hour Final', the last late news on
American television, used to
broadcast reports from the front
that did not reflect the true situa-
tion at the time. Kienholz took a
domestic idyll and introduced
into it the daily butchery that was
received as casually as any other
broadcast. MK

R.B. Kitaj b. 1932

Thoughts about Violence 1962

Oil on canvas, collage elements

152.2 x 152.5 cm

Hamburger Kunsthalle

A picture with footnotes; every motif and every piece of text demands to be read and studied. American Indian pictorial signs taken by the artist from an ethnology magazine are combined with passages from a work by the philosopher Georges Sorel and contemporary political newspaper cuttings. Their common theme is violence. R.B. Kitaj responds with rigorous objectivity and distance to the enormous amount of violence that confronts us in the media every day. Anything that could seem expressive is withdrawn, even traces of the painting process are shaved off with a razor-blade to enhance the austerity of the surface. It is precisely as the title promises: violence is considered here, and not presented vividly.

But something is presented vividly in this picture, and that is a distrust of glib formulae. For this reason Kitaj wrote on a reproduction of this picture: "I assume that true peace resembles true art; it is produced with care, imagination and luck. Unlike fate it is a piece of freedom. Is that right?? I'm not so sure." CH

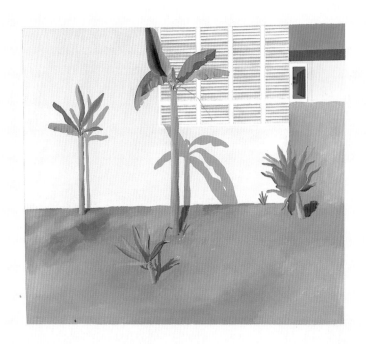

David Hockney b. 1937
Hollywood Garden 1966
Acrylic on canvas
183 x 183 cm
Hamburger Kunsthalle

David Hockney painted 'Hollywood Garden' two years after moving from London to Los Angeles. He was fascinated by his new surroundings, and the light and colours of California, and his style changed fundamentally. His previous painterly approach gives way to a two-dimensional quality: no attempt is made at a three-dimensional effect.

The only things that give even a hint of space are the shadows cast on the house wall and on the ground by the palms. Typically, Hockney leaves the shadow of the right-hand palm incomplete. Painting has its own laws. The fact that the image is placed on the canvas almost as a square emphasizes the artificial quality of Californian reality. The dull effect of the acrylic colours also contributes to this. UL

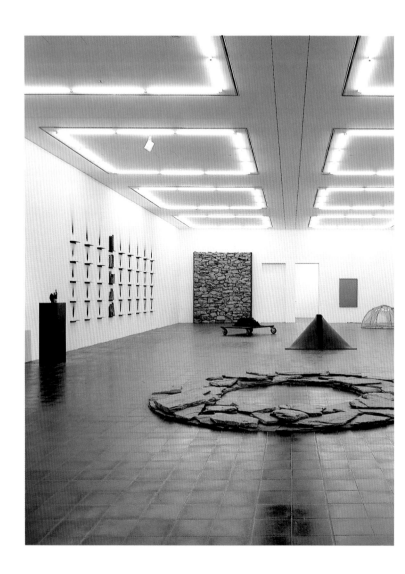

Materials in Art since 1960

In the sixties everyday materials like felt, lead, coal and ash that had hitherto been alien to art started to appear on the art scene. The political events of this period also changed the way in which art was seen. Many artists began to reject painting because it stood for a bourgeois world that was now a thing of the past. Various important approaches to a new material language were made after this particular "departure from the picture": Arte Povera in Italy, the art of poor materials (Jannis Kounellis, Mario Merz), and in the USA Antiform, which went against the traditional ideals of form (Robert Morris, Richard Serra). Everyday materials played a central role for Fluxus. Alongside this, individual artists who are still very influential today, like Joseph Beuys and Reiner Ruthenbeck took up powerful positions.

Arte Povera was the European response to American Pop Art. Unlike Pop Art, which always stressed a particular mass-produced brand and the way in which it was marketed, Arte Povera aimed at the existential. It sees itself as a critical commentary on an industrial society that thinks in material terms.

But the American artists' exploration of materials was directed at industrially processed raw materials that had had no part to play in sculpture until then. Artists had been subordinating material to form for centuries. The new question was: what does material do to form?

OW

left, on the wall
Jannis Kounellis b. 1936
Untitled 1984
Wall installation with 40 soot marks above iron shelves and pieces of wood on 5 shelves
each shelf 40 x 13 cm
overall area 300 x 700 cm
Hamburger Kunsthalle, property of the Stiftung zur Förderung der Hamburgischen Kunstsammlungen (Foundation for the Promotion of Hamburg Art Collections)

Soot marks rising from shelves in Jannis Kounellis's 1984 work are a sign of a transformation process. They are traces of the past and at the same time shades of a future change. Each soot mark is different and delineates the power of fire and the draughts that blew the soot against the wall. They breathe life into the strict arrangement of the shelves, which is also broken up by another series of shelves with pieces of wood found by the artist. These traces of use and time emphasize the formal variety and living origin of the soot marks, and form a contrast with the rigidity of the metal shelves. At the same time the wood seems like material for future pictures, while the old, traditional pictures appear to have been burnt on the shelves.

OW

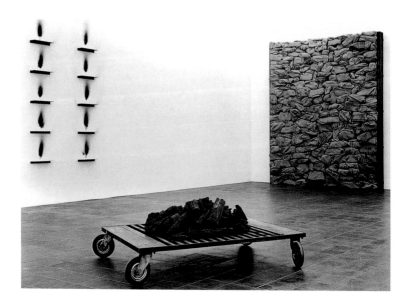

Jannis Kounellis
Untitled 1968
Trolley made of steel and wood with
solid rubber tyres, charcoal
30 x 120 x 120 cm

Untitled 1996
Stones, jute sacks, iron girders
350 x 300 x 36 cm

Both: Hamburger Kunsthalle

The 1968 work also addresses
transformation and change. Here,
instead of a plinth, Kounellis uses
a trolley of the kind used for trans-
porting goods. Again he piles
something produced by fire on
top of it: this time it is charcoal,
an energy reservoir.

In his new work for the Contem-
porary Art Wing Kounellis piled
large pieces of sandstone covered
in jute sacks on top of each
other between two iron girders.
This produced a wall and also a
pictorial sculpture. The jute sacks
were taken out of the commercial

cycle in which they are usually
involved. The writing on them
reminds us of what they used
to contain: food and fuel, both
essential for life. Combining
them with the weight of the con-
cealed stone makes them into a
picture – a picture made by
other means. OW

Mario Merz b. 1925
1 + 1 = 2 1971
Iron, neon tubes Ø 200 cm,
height 100 cm
Hamburger Kunsthalle

Mario Merz's igloos, which he has
been building since 1968, are
based on Eskimo snow huts and
the domed tents used by nomads,
who pitch them only provisionally
and for a short time. Merz retains
this flexibility, for example by
fastening the wire netting on to the
tubes with D-clamps. A mysterious
sense of flowing movement is
created by using modern techno-

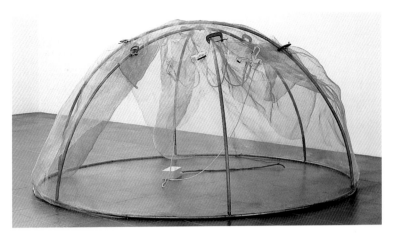

logy, the flickering fluorescent tubes.

The simple addition alludes to a mathematical principle to which Merz constantly returns: the Fibonacci series, named after a mathematician who lived in Pisa in the 13th century. Each number in this sequence is the sum of the two previous numbers: 1, 1, 2, 3, 5, 8, 13 . . . Artistically this principle, which forms the structural basis of many natural phenomena, can be represented in the form of an opening spiral, which – addressed three-dimensionally – also occurs in the vault of a dome. So Merz's igloo is not just a model of a simple dwelling, but at the same time illustrates the structural principle of a world that is evolving and open to change.

CH

Robert Morris b. 1931
Untitled 1967
Felt, metal eyes 190 x 400 x 220 cm
Hamburger Kunsthalle

Felt has very particular qualities. It is flexible, but bulkier than other fabrics, and can be manipulated only to a certain extent: it can be folded and rolled, laid or hung up. In each of these cases it takes on a specific shape because of its peculiar qualities. Robert Morris has been examining the relationship between material and treatment in his works in felt since 1967, and is still adding to the group.

In this early work dating from 1967, subtitled 'Felt Tangle', pieces of differently – largely geometri-

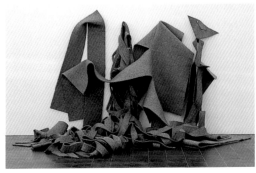

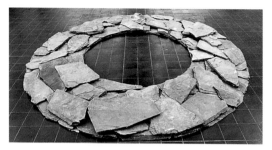

'Slate Ring', which Long has set up inside, is intended to be permanent. The circle is one of the basic forms that man has used from time immemorial to confront nature in all her power and force, to discover and to interpret her fundamental order. Long picks up at this point: he sees his work as a balance between what nature prescribes and man's desire to create and design, as expressed in abstract ideas.

cally – cut felt that have become entangled with each other and spread across the floor are suspended from a total of twelve fastenings. This sculpture is not intended to develop forms but to let actions become visible in the material and thus demonstrate relations between human beings and real space. MK

Richard Long b. 1945
Slate Ring 1985
Slate Ø 400 cm
Loan from a private collection

Detached from the material's natural context and arranged in a circle, these slate slabs become a sculpture. The work relates to Richard Long's landscape experiences. From 1965 onwards Long went on long walking tours of England and Ireland, of Africa, South America and India. He made sculptures en route, using materials that he found on the spot: geometrical signs – Land Art. They are embedded in their natural surroundings, and return to the rhythms of nature. But a work like

Richard Serra b. 1939
To Lift 1967
Vulcanized rubber c. 91.5 x 203 cm
Reinhard Onnasch Collection in the Hamburger Kunsthalle

Richard Serra shifted his artistic interest from the end product to the process. A simple action, lifting, is captured in 'To Lift' and vividly expresses the language of the material: a simple vulcanite mat was placed in such a way that it can stand unsupported and develop a form of its own. The material's own weight distorts the rubber, and the forces that

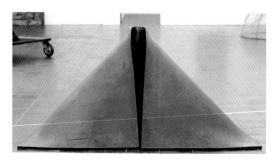

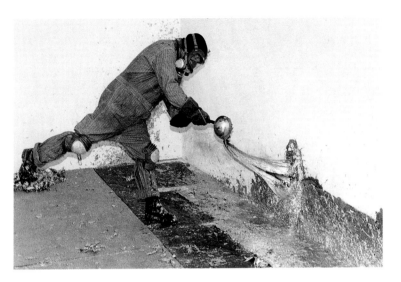

create the shape are borne by the floor. Bearing and load, gravity and balance are key concepts in Serra's work. OP

Richard Serra
"Measurements" of Time:
(Seeing is Believing) Marius Dietrich, Ernst Fuchs, Heinz Klettke, Andreas Krueger, Gunther Maria Kolck, Jochen Möhle 1996
5 bars of thrown lead
50 x 1150 x 495 cm
Hamburger Kunsthalle

This floor work is one of the group of 'Splashings' or 'Castings' that was started in the Castelli Warehouse in New York in 1968. The majority of these works were temporary installations, but the Hamburg work was intended to be permanent, and is also the largest of the 'Splashings'. Over 13 tons of scrap lead were melted in the week that it took to complete the work. Richard Serra used a large ladle to throw the metal at the point where the wall met the floor. The molten metal immediately acquired a shape as it cooled. Four of the elements, cast one after the other, were eased away from the floor and wall, tilted and shifted into the room one after the other. The fifth chunk of metal remained firmly fixed in the angle between the wall and the floor. The low melting point, softness and ductility of lead are essential if the work is to find a shape. But the material qualities become independent: in the course of time the lead gives way and sinks; a real-time system in the form of concrete sedimentation, and authentic evidence of time in one. The iridescence also changes to a dull grey. OP

Joseph Beuys 1921–1986
Hirsch (Stag) 1958/84
Aluminium 46 x 175 x 105 cm
Loan from a private collection

'Hirsch' is a test casting in aluminium based on a wooden sculpture that was part of the 'Hirschdenkmäler' (Stag Monuments) installation at the Berlin 'Zeitgeist' exhibition in 1982. During this exhibition Beuys decided to cast parts of the 'Hirschdenkmäler'. They were built into 'Blitzschlag mit Lichtschein auf Hirsch' (Lightning-flash with Beam of Light on Stag), but Beuys detached the test casting from this context as a work in its own right. The stag is a central motif in Beuys's work, recurring frequently in his drawings, sculptures and installations. Usually it is an animal that has died or been killed, with its legs stretched outwards, and recognizable in the ensemble as a stag seen from above. Beuys has broadened the concept of his early wooden sculpture in the aluminium casting and given it a shape that is up-to-date for him: the cast sculpture is the end product of a manufacturing process that started with a shapeless mass. Beuys saw this transformation from one state into another as an underlying principle of life. MK

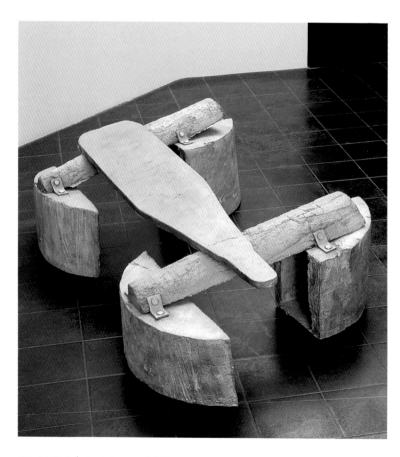

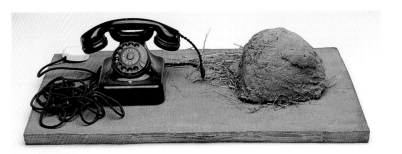

Joseph Beuys
Erdtelefon (Earth Telephone)
1968
Telephone, clod of earth with grass,
connecting cable on a
wooden board 20 x 47 x 76 cm
Loan from a private collection

Joseph Beuys put a black bakelite
telephone receiver on a wooden
board and added the connecting
cable and socket. Next to this he
placed a lump of clay that is of
roughly the same volume as the
telephone. He dug up the clod
with a spade and placed the top-
soil on the board in such a way
that the grass can be seen under
the clay. The clump of earth and
the telephone embody two dif-
ferent ways of expressing creative
processes: the shaping of clay,
which Beuys demonstrates here by
digging up a piece of earth, is a
three-dimensional creative process
– a form is created from a mass.
This is juxtaposed with an imma-
terial creative process in the shape
of the telephone: he considered
that speaking, the vocalization
associated with this and the
thought process that precedes it,
was on a par with artistic creation
as another means of finding form.
This thought led him to the insight
that "every human being is an
artist". MK

Joseph Beuys
Thermisch/plastisches Urmeter
(Thermal/plastic standard
measure) 1984
Copper container 17.1 x 38 x 83 cm
Copper tube (with iron), four parts
joined by couplers 157 x 2 cm
Showcase 90 x 180 x 78 cm
Table 78.5 x 199.5 x 97.5 cm
Hamburger Kunsthalle

The 'thermisch/plastisches
Urmeter' – a hollow copper
cuboid and an iron tube – is a relic
from the 1984 'Skulptur in 20. Jahr-
hundert' exhibition in Basel. On
that occasion the copper box was
used to create steam, which pas-
sed into the exhibition gallery with
the aid of the tube. As can be seen
in the video recording associated
with the work, the steam came
out of the thin tube in a small
cloud close to the floor, where
visitors could look at it. This
discarded apparatus shows how
Beuys used his works to create

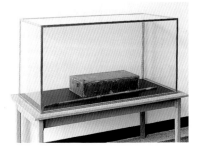

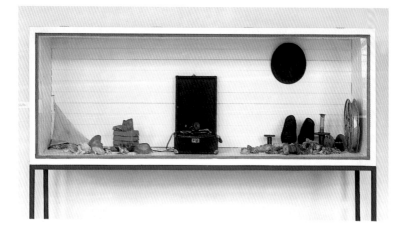

meaning: as a functional apparatus, the object exhibited draws attention to a process of which it is only the carrier. Here the process in question was the vaporization of water, the transformation from a liquid to a gaseous state. As the title indicated, Beuys demonstrated his sculptural principle with the aid of thermal processes. MK

Joseph Beuys
Vitrine (Showcase) 1981
206.5 x 230 x 50 cm
Hamburger Kunsthalle

In 1970 Joseph Beuys settled for a particular kind of showcase: a wooden box, only open at the front with a pane of glass, is supported by a stand made of square iron bars. The collection of objects, arranged by Beuys himself, comes from actions and an installation that he showed in the Galerie René Block in Berlin. The action known as 'Der Chef' (The Boss) took place there on 1 December 1964. The Galerie René Block closed down on 15 September 1979; the final exhibition was Beuys's

Environment 'Ja, jetzt brechen wir hier den Scheiß ab' (Yes, the crap's over now). The wedge of fat comes from the 'Chef' action, the pieces of wax came into being in the 'Eurasia' action (1966), the gramophone with black pudding was used in the 'Ich suche dich freizulassen (machen)' (I'm trying to set (make) you free) in 1969. Things that were once part of an activity or originally presented in a different context have now retired from the action. But the objects still have a certain charisma. HRL

Arthur Koepcke 1928–1977
Reading/work-piece No 63
1963
Mixed paints on canvas 170 x 71 cm
Hamburger Kunsthalle

Arthur Koepcke liked to see works of art as signs and puzzles. His 'Reading/work-pieces' are unrolled display charts including textual and pictorial collages: picture puzzles, plans, sketches, schemes and instructions, catch-phrases and abbreviations of the kind found in comics that address the viewer

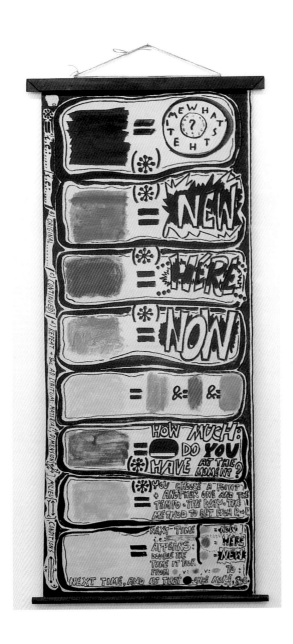

directly. In 'Reading/work-piece No 63', Koepcke effortlessly sets up equations between colours and shapes, between the signal-value of the colours and the penetrative power of exclamations. "NEW, HERE, NOW" and questions like "What's the time?" are Koepcke's direct appeal to the viewer's presence. Poetic links, tensions between intellectual and emotional understanding, are here to be discovered. Koepcke challenges the viewer to play an active part: "Fill with own imagination" can be read in one black field. DZ

Robert Filliou 1926–1987
2 x 1 = 3 NO 1x 2 = 2 1961
Wood, paper, metal 65 x 35 x 7 cm
Cremer Collection in the Hamburger
Kunsthalle

In '2 x 1 = 3 NO 1x 2 = 2' Robert
Fillliou shows his abilities as a
games-lover and a lateral thinker.

The equation stated in chattering
faces – one of them packed full of
text – is corrected by the equation
in the tin. Filliou joined the Fluxus
artists in 1962, after studying
economics and working as an eco-
nomic advisor in the Far East.
'Fluxus' is derived from the Latin
verb 'fluere' (to flow). Fluxus art

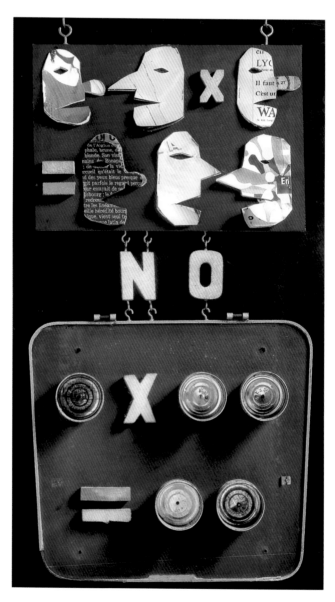

is concerned with creative processes on a basis of fluid change and transformation. Its characteristics are spontaneity, chance, the reversal of logical premises and active participation by the spectator. Filliou's work is directed against the exact sciences. His poetic mathematics undermines the notion of fixed quantities and gives calculations a sense of flow. DZ

Dieter Roth b. 1930
Sannahs Zwerg (Sannah's Dwarf)
1969
Plastic, chocolate 53 x 22 x 22 cm
Cremer Collection in the Hamburger Kunsthalle

Dieter Roth finds his expressive resources in ordinary things. His organic materials slowly change – they bulge, collapse, go mouldy or lumpy, rot, break up, flake off. For 'Sannahs Zwerg' Roth covered a plastic garden gnome with chocolate. Only the tip of the cap is left sticking out of the chocolate cylinder. In this context the chocolate no longer suggests something edible. Its cracked surface looks like rusty iron or the bark of a tree. Roth relates the transience of the materials to that of his own body, and at the same time draws attention to the different pace of this decay – "The images will survive me . . . they will last as images, even though they may come to an end as material." The materials he uses make the process of decay into an artistic theme.

DZ

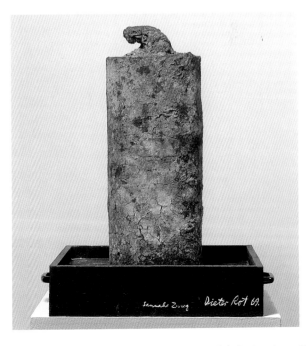

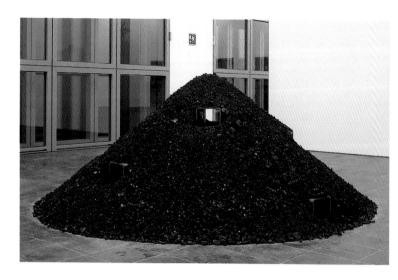

Reiner Ruthenbeck b. 1937
Aschehaufen VI (Ash-heap VI)
1968/71
4 square iron tubes, volcanic ash
Length of tubes 60 cm, 110 cm,
150 cm and 200 cm,
Ø each 16 x 16 cm
Hamburger Kunsthalle

Reiner Ruthenbeck's works are
made up of contrasts: hard and
soft, light and heavy, tight and
loose are the qualities that he
brings together in his sculptures.
Ruthenbeck's forms are not sym-
bols, the material used in his work
does not tell a story, it is unused,
austere and is employed only for
its physical qualities – without any
attempt at evaluation, Thus in
'Aschehaufen VI' Ruthenbeck
brings four square iron tubes and
volcanic ash together. Two funda-
mentally different materials are
combined to form temporary unity
in the abstract geometrical form of
the cone, a unity that could be vio-
lated or destroyed at any time. In
the age of the stream of informa-
tion that inundates everything, a
time of relativization and the
imposition of technology,
Ruthenbeck transform elemental
facts into works of great
meditative force. CH

Franz Erhard Walther b. 1939
Zwölf Packpapierpackungen
(Twelve Wrapping-paper Packages)
1963
Wrapping-paper, glue
each 76.2 – 77.2 x 49.6 x 51 cm
Hamburger Kunsthalle

Rote Scheibe mit vier Bändern
(Zustand zusammengefaltet)
(Red Disk with four bands
[folded state]) 1963
Wood, cotton fabric
Ø 190 cm
Hamburger Kunsthalle

Zwei gelbe Kästen
(Two Yellow Boxes) 1962/63
Corrugated cardboard, cardboard,
paper, casein paint, binder, pigment,
glue
31.5 x 22.5 x 11.5 cm; 66 x 54 x 35 cm
Hamburger Kunsthalle

96 Nesselplatten
(96 Untreated Cotton Fabric Plates)
1963/64
Untreated cotton fabric
each 20 x 20 x 2.7 cm
Hamburger Kunsthalle. Gift by Otto
Versand to mark the opening of the
Contemporary Art Wing in 1997

Franz Erhard Walther created the
'Zwei gelbe Kästen' as a means of
rejecting traditional pictorial and
sculptural forms. Their pure pig-
ment covering is reminiscent of
Yves Klein.

Instead of seeing paper exclus-
ively as a support for pictures,
Walther makes use of its specific
qualities in 'Zwölf Packpapier-
packungen'. As a flat body, paper
can show structures, caused by
tension when drying, for example.
The two sides are of equal status,
and suggest an action like leafing
through a book. Walther came to
relate his work increasingly to this
kind of handling. In the '96 Nessel-
platten' he is chiefly interested in
changes of state: blocks, and the
various ways in which they can be
stored. The 'Rote Scheibe', which
consists of wooden segments
sewn into reddish-brown fabric
and four bands, can adopt various
states: folded, laid out on the floor
or hung in different ways, as a
circle, for example. Here Walther is
developing a "different concept of
work": the work has a shape, but
there must be an additional pro-
cess of shaping in confrontation
with the user. Everything that is
important in handling the objects
– thought, language, place, time –
becomes part of the material of
the work, which in this case is
constituted only by action.

BF

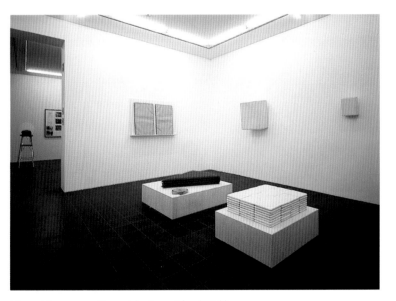

View of the room with work by Franz Erhard Walther

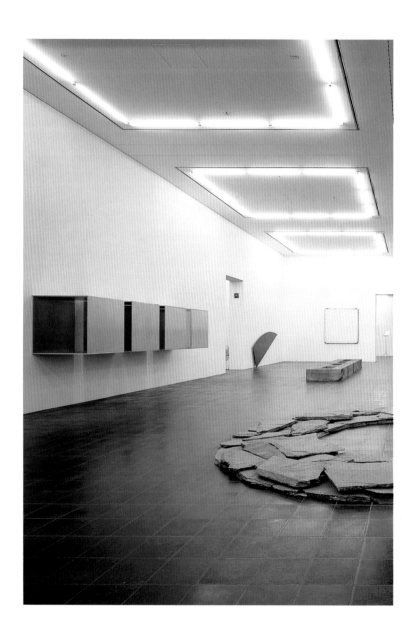

Minimal Art

"A great deal has been written about Minimal Art recently, but I have not yet found anyone who would admit to doing anything like that", wrote Sol LeWitt, and Donald Judd, Dan Flavin and Robert Morris thought similarly. Only Carl Andre accepted the definition that art historians had given to this movement that emerged at the same time as Pop Art in the USA. For a few years radical reduction of form was common to these artists. Simple geometrical figures and solids like squares, cubes or cuboids were realized in industrially manufactured materials (metal, perspex, neon tubes). Frequently the individual elements are arranged in series, which eliminated any possibility of a hierarchy and any sense of composition, both of which are subject to subjective decisions by the artist. Dignified formulae like plinth and frame were abandoned. Individual expression was replaced by statements and facts that were open to examination. Sixties art critics saw these clearly structured and totally unmysterious works as representing faith in technical rationality, and took their unhierarchical structure as an expression of democratic awareness.

Interest in this unwieldy art has recently been reawakened. It may be the works' austere straight lines, or the lucidity with which intention and execution are brought together that give us pause in the midst of our post-Modern ducking and diving: what you see is what is there: no more and no less. CH

1 *left, on the wall*
Donald Judd 1928–1994
Untitled 1984
4 parts, aluminium, perspex
each 100 x 100 x 100 cm
Loan from a private collection

Four powerful, identical cubes in brushed aluminium with panes of green perspex are hung in a row on the wall. Viewers are supposed to confront them as an experience of self, rather than merely as an experience of objects. They consider the works from various points of view, and see themselves reflected in the green panes. The way in which they re staggered makes the visitors seem to disappear. The form is permeated with space and light: the perspex reveals the interior and opens up the volume. As the observer moves, perception becomes the sum of an indeterminate sequence of connections and perspective views.

OP

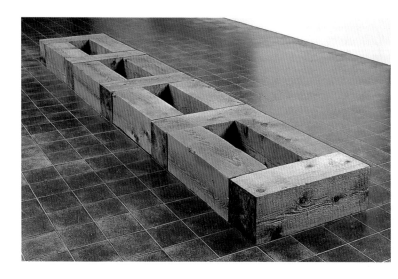

Carl Andre b. 1930
Romartyr Hamburg 1989 1989
13 parts, cedar each 30 x 30 x 90 cm
30 x 90 x 510 cm overall
Loan from Galerie Konrad Fischer

Carl Andre created his first wooden sculptures under the influence of the work of Romanian sculptor Constantin Brancius in the late fifties. In 1960 he started his 'Element Series', a group of works based on the module of a standard wooden plank. They consist of serially manufactured formal elements that are always identical within a particular work; Andre was not able to realize them until 1970 onwards, for financial reasons.

'Romartyr', which was created in 1989 for a group exhibition outside the Deichtorhallen in Hamburg, consists of 12 blocks of wood. The title is made up of the words Roma (Rome) and Martyrium (martyrdom), and refers to a Hamburg demonstration for the right to remain of Roma and Sinti gypsies that took place in 1989 at the same time as the dedication of Sol LeWitt's memorial to murdered Jews in Altona. MK

Robert Mangold b. 1937
$^1\!/_2$ Series Blue 1968
2 parts, acrylic on hardboard
each 122 x 122 cm
Loan from a private collection

In the early sixties, when artists were proclaiming the "death of painting", Robert Mangold was by no means convinced that the medium's possibilities were exhausted. He made use of the insights of Minimal Art when arriving at his concept of painting: reduction of vocabulary to elemental aspects like surface, form, colour and line. Mangold raised these elements, which are intended to work together as equals, to the status of content in his pictures. He uses a roller to apply matt acrylic paint to the surface of the hardboard sheets, thus emphasizing the two-dimensional quality of the painting. He structures the surface with grooves and lines created by

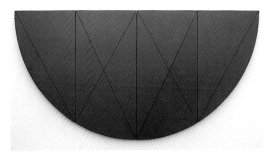

mounting pictorial sections next to each other. This avoids any illusion of depth and makes the viewer aware of the edge of the picture. The free form of the outline allows Mangold to underline the work's quality as a thing and establishes a new relationship with the space it occupies. In 1968, in the group of works called 'WXV' he derived other pictures with the same colouring from the basic semicircular format, all representing one section of the basic form. BF

Robert Ryman b. 1960
Division 1980
Oil on canvas, steel holder
160 x 152 cm
Loan from a private collection

Robert Ryman calls his pictures realistic paintings. They were produced from the mid fifties and are thus precursors of Minimal Art to some extent. Ryman makes painting into the subject of his pictures, without referring to a reality outside colour, line and support, and without any semblance of space or depth. He paints only in white, and his pictures are always square, but he successfully develops an unexpected variety of painterly effects by altering his brushwork and by his choice of

background and support. He also makes the way in which the picture is hung and the shadows it casts on the wall part of the overall effect. In 'Division', Ryman applied the paint to the canvas in short, even but at the same time quite unschematic strokes. The viewer experiences the painting – in the alternation of matt and gloss lines, in the ridges of paint, which cast short shadows, and in the constant presence of the ground – as a living, vibrant surface hanging on the wall and surrounded by a field of soft shadow. Radical reduction in fact opens up an abundance and diversity of painterly expression for Ryman, in which the care he takes conveys to us that we are not at the much-trumpeted end of painting, but at a new beginning.
 CH

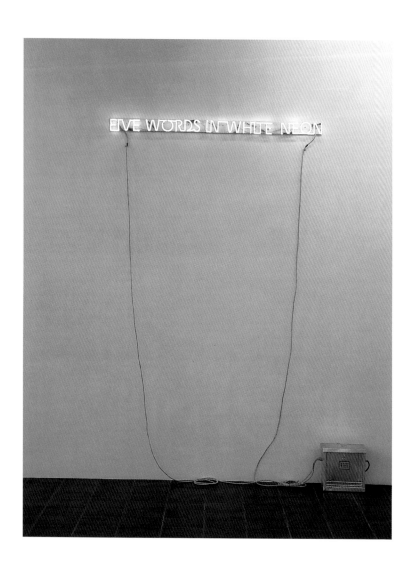

Concept Art

Concept art is art about art. The "death of painting" asks questions about how art comes into being and how it is exhibited and collected. Here rejecting the picture means questioning its conditions. The subject is not the picture that is to be painted, but the different ways in which it can be seen. The crucial thing is the idea, not the execution, which is handed over to the owner of the work, together with a set of instructions. The origins of Concept Art are closely linked with the protest movements of the sixties: rebellion against the Vietnam War and the student revolts. Paintings were considered a fetish, and marketing them the quintessence of a paralysed culture. Artists wanted to leave the world of galleries and studios and replace it with a kind of artistic public relations work. For many artists the starting-point was Minimal Art. Its medium was language. Artists were concerned with the new information systems, and with measuring space and time. The first Concept artists include Joseph Kosuth, Douglas Huebler, Robert Barry, Lawrence Weiner, Sol LeWitt and Hanne Darboven. Kosuth organized one of the new movement's first exhibitions in New York in 1968. He called it 'Exhibition of Normal Art', and intended it as a commentary on 'Popular Art'. Unlike Pop Art, with its cult of the star, Kosuth relied on the everyday use of language and illustrations.

OW

◁ **Joseph Kosuth** b. 1945
Five Words in White Neon 1965
Neon tubes 8 x 150 cm
Elisabeth and Gerhard Sohst Collection
in the Hamburger Kunsthalle

Light has a particular part to play in the dematerialization of art. Joseph Kosuth's work 'Five Words in White Neon' is to be seen in this context. But Kosuth removes any metaphysical significance from light as a working material. It is what the viewer sees – a tautology of words and material: five words in white neon. In this way he is postulating the material qualities of light and language. He works with the invisible and its material.

OW

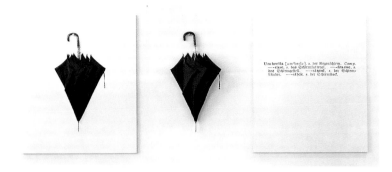

Joseph Kosuth
One and Three Umbrellas 1965
Photographs, umbrella 120 x 360 cm
Elisabeth and Gerhard Sohst Collection
in the Hamburger Kunsthalle

An umbrella is an umbrella is an umbrella. There is no escaping this circular argument in Joseph Kosuth's 'One and Three Umbrellas'. The work is in three parts: an umbrella, a photograph of it and a dictionary definition of the word umbrella. These three parts are reminiscent of the traditional form of the triptych, but Kosuth is not interested in the more profound spiritual significance of that form. His work is like an experimental procedure: one and the same thing is exhibited three times. Object, copy and language are allotted equal status. It suggests the idea of a tautology, in which something is doubled by putting together different words for the same thing. Seen in isolation, the ways of presenting the umbrella do not enter into a dialogue. But every-thing fits together. Kosuth shows us the basic structure for a picture that is assembled only in our thoughts. OW

Lawrence Weiner b. 1940
Statement 245 1970
Elisabeth and Gerhard Sohst Collection
in the Hamburger Kunsthalle

Lawrence Weiner enshrined the distinction between a work and its execution in his three statements on Concept Art, thus cancelling the traditional image of the artist as creator. Anyone can do it, the work can also exist as a mere idea, it does not have to be realized. From 1968 onwards Weiner called his works, which he does not realize himself, 'Statements'. Some of them have been realized. Others were implemented when their text appeared written on a wall or in a book. The text can also be spoken. Weiner thus detaches himself completely from the presentation of his art. The owners, whom he makes responsible for realization, are registered in New York. In this way he maintains the unique quality of his

OVERTURNED. TURNEDOVER.

AND OVERTURNED. AND TURNEDOVER.

work, even though there are many possible forms in which it can appear. OW

Robert Barry b. 1928
Inert Gas Series, Argon (AR)
1969
Catalogue page, photographs, colour slide 50 x 50 cm
Elisabeth and Gerhard Sohst Collection in the Hamburger Kunsthalle

Following on from his Minimalist painting period, Robert Barry's work now circles around things that cannot be seen but can probably be imagined. Two colour photographs and a slide capture his actions of 4 and 15 March 1969: Barry allowed a quantity of the inert gas argon to escape from a bottle on the beach at Santa Monica. He explained that he was concerned to allow a limited volume, one litre, of gas to achieve unlimited extent. This developed an art that lies beyond perception, which is nevertheless derived from material and its spatial extent. Thus Concept Art is directed against monodimensional notions of the image, and stimulates our imagination. OW

Hanne Darboven b. 1941
Konstruktion N. Y.
(Construction N. Y.) 1966/67
Ball-point pen and ink on paper
86 drawings each 70 x 50 cm
Loaned by the artist

Hanne Darboven studied in Hamburg, then went to New York in 1966. The series of structural drawings that she contributed to the first important Concept Art exhibitions date from immediately after her arrival there. These works clearly show the system that still forms the basis of her work: she moves from drawing to number

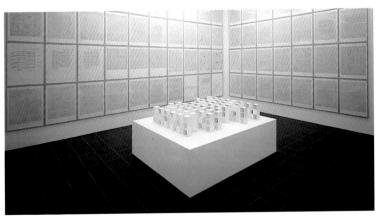

Hanne Darboven, 'Konstruktion N. Y.' (Construction N.Y.), 1966/67; in the centre of Sol Lewitt's room: 'All Three-Part Variations of Three Different Kinds of Cubes', 1968

and from number to word. Darboven drew lines on to graph paper with millimetre squares, and their extent corresponded to numbers. From these numbers she developed horizontal sums of digits and repetitions of various written numerals. In later works a handwritten, wordless script using U-bends and the word 'heute' (today), crossed out, are additional features. All these elements demonstrate the passage of time, including the time it takes Darboven to write, which is recorded by the enormous scope of the various series. Darboven derives her algebraic columns of figures from geometry. This associates her work with Sol LeWitt's 1968 cubes.

OW

Sol LeWitt b. 1928
A Straight Line …
a Not Straight Line 1974
Wall drawing no. 234
Variable dimensions according to version
Elisabeth and Gerhard Sohst Collection in the Hamburger Kunsthalle

Sol LeWitt has been exploring possible variations on lines in his wall drawings since 1968. He fixes a system for doing this in a set of instructions. These instructions change owner in the form of a certificate, and are the only fixed element in these numbered wall drawings. LeWitt leaves the owner to realize the work. He published this procedure in his 'Statements on Concept Art', which are among the early written material on Concept Art. In 'Wall drawing no. 234' two types of line – straight and not straight – are related to the dimensions of the wall. LeWitt's origins in Minimal Art can be seen in this reductive approach. OW

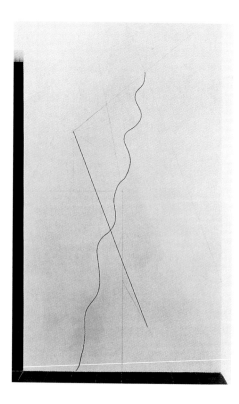

Installations I

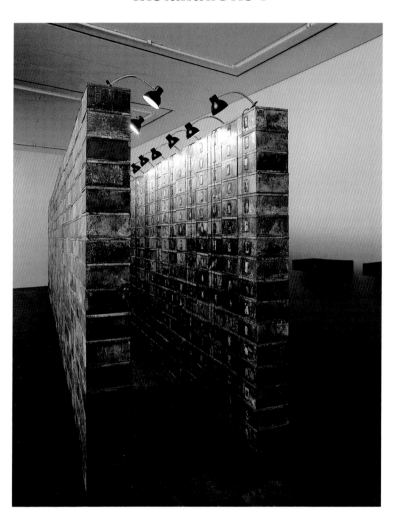

Christian Boltanski b. 1944
Réserve: Les Suisses morts 1990
approx. 1,300 biscuit tins, photographs,
lamps, cable 195 x 115 x 820 cm
Hamburger Kunsthalle.
Property of the Stiftung zur
Förderung der Hamburgischen
Kunstsammlungen

The narrow passageway between
the piles of tin boxes contains an
enormous number of anonymous
black-and-white portrait photo-
graphs. The arrangement is like that
of a repository or archive, where a
complete set of personal details is
kept under the glare of office lamps
and with bureaucratic precision.
The tin boxes, labelled with photo-
graphs, inadvertently become
elaborately lit reliquaries. The image
of death does not occur in this
temporary memorial: these are
photographs of living people.

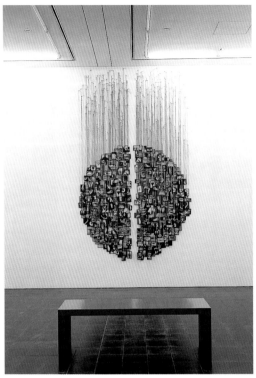

Annette Messager
b. 1943
Mes Voeux 1992
Framed photographs,
string
c. 300 x 100 cm
Hamburger Kunsthalle

And here we have layers and piles, frames covering other frames. Black-and-white photographs of parts of the human body in plain black frames are suspended on long threads in such a way that they adopt a circular form. Annette Messager draws her inspiration from the votive gifts at places of pilgrimage with their clutter of painted panels, photographs and limbs in wood or wax. They are all evidence of human misery, but also of the happier moments in life. Annette Messager appropriates this narrative method in order to formulate her wishes. But she is not just recording the frailty of the body, but also its ability to feel. Faces and bodies are broken down into surprising parts: the nose seen from below, tongues sticking out obscenely, open lips, navels, nipples, male genitals. She plays with the attractive qualities of the individual parts of the body, while at the same scorning any kind of voyeurism. Photography in all its shamelessness and insolence is enjoyed and rejected. BF

Christian Boltanski chose Swiss subjects as he feels that they symbolize happy, healthy people. And yet death worms its way in: all the photographs are taken from death notices. Boltanski is on the track of transience. He is interested in disappearance, the strange passage from a personality to nothing, being transformed into something nameless. All this large number of 'Dead Swiss' seem the same and as interchangeable as the shabby, anonymous biscuit tins. And yet this mass is made up of individuals, each of whom is important and deserves to be remembered.

BF

Ilya Kabakov b. 1933
Healing with Painting 1996
Installation
Hamburger Kunsthalle

Ilya Kabakov's installations are part of a universal work of art about the Soviet world. He created this room specially for the Hamburger Kunsthalle. The viewer enters a hospital ward through an old door that signals the gloomy poverty of the whole ambience even from the outside. Two treatment rooms each contain a bed and a large landscape painting, and Baroque music is playing. A text is posted, giving information about a therapy that uses art to cure nervous and emotional disorders: patients are expected to plunge into the inner world of a picture by looking at it intensively. Are they escaping from the cramped treatment room into an unreal fantasy world?

The installation requires its viewers to be both close and distant. They are spectators and patients at the same time. The spatial isolation and the musical accompaniment compel them to reflect. According to Kabakov the pictures are anonymous (though he may have painted them himself). They show the "beautiful" bits from a landscape that seems ideal, and yet kitschy for the same reason; at the same time they bear some of the marks of Soviet Realism: ironic painting that nevertheless pretends to have healing properties.

DZ

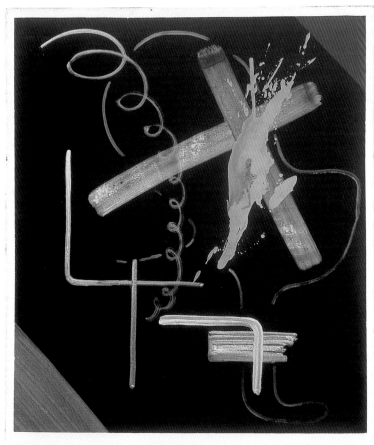

Moderne Kunst

Painting on Painting

Questions about artistic materials, their composition and qualities, have in many ways been at the centre of discussion in sculptural circles since 1960, and painters have been addressing comparable problems in terms of their own medium. They examine the inherent laws to which pictures conform, as revealed in their material qualities. Thus the art of Gerhard Richter, Sigmar Polke, Georg Baselitz and Markus Lüpertz can be called "painting on painting". In the sixties, painting's relationship with the mass media was the central issue. Transferred into painting, the newspaper photograph becomes unique. This unique quality relates to the reality and the aesthetic qualities of the photograph, but also justifies its existence in its own right.

Gerhard Richter analyses individual aspects of painting: the picture as a place for colour, colour application as a pictorial subject. Sigmar Polke takes established aesthetic material as the starting-point for his pictures, either as printed or transparent material or as freely flowing colour. The artistic act is an action that executes or intervenes, thus the picture becomes a mysterious place. Georg Baselitz remains figurative and is nevertheless not descriptive. He has been turning his motifs upside-down since 1969, thus shifting attention from the motif to the picture as object. His free painting technique is thus a device used en route to 'pure painting'. Markus Lüpertz often paints his pictures in series. He finds his way from stylistic painting to the painting of motifs, but he releases the motifs from the meanings that are imposed upon them.　　　DZ

◁ **Sigmar Polke**　b. 1941

Moderne Kunst (Modern Art)
1968
Artificial resin and oil on canvas
150 x 125 cm
Loan from a private collection

All cartoonists know what 'Modern Art' looks like: a few colourful loops, lines and blobs – and the work of art is finished. As people who like this kind of art we know better, and get annoyed about the stupidity of the mockers. And then along comes Sigmar Polke in 1968 and paints exactly what the stupid jokes describe. It would be pointless to try to find evidence in this picture of banality being transformed spiritually and artistically into a work of art.

Where is the back door for those enlightened people who are prepared to try to come to terms with modern art? They are offended. And what is the point of giving offence in this way? Perhaps a line of thought that goes something like this: the overwhelming majority of the public identifies – still, probably – modern art with this picture. But as popular opinion would be just as likely to vote for the abolition of modern art as for the introduction of the death penalty, this picture would be gen-

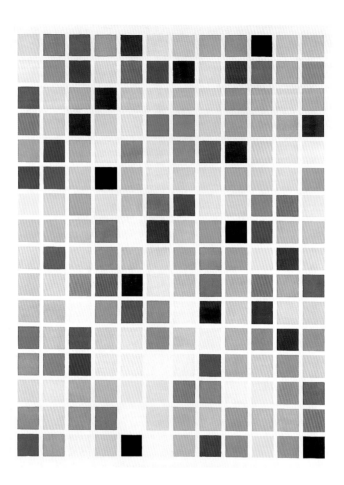

erally accepted as it confirms the general idea of modern art. And so it only offends lovers of modern art! According to this, how far does the power of modern art extend?

HRL

Gerhard Richter b. 1932
192 Farben (192 Colours) 1966
Gloss paint on canvas 200 x 150 cm
Elisabeth and Gerhard Sohst Collection in the Hamburger Kunsthalle

Gerhard Richter has always remained loyal to the panel painting. In 1961, at a time of general art-historical upheaval, he moved to the West from East Germany, where he had been trained entirely in the spirit of Social Realism. He produced his first series of 'colour panels' in 1966, after a phase of largely black-and-white pictures. His starting point was the colour charts that are usually found in the trade. Colour does not appear as a quality of figures or objects in these works. Colour is arranged randomly, quite neutrally and without indicating expressive or symbolic values: as material for future pictures. And for Gerhard Richter painting always means thinking

about making pictures. A work like '192 Farben' opens up new possibilities with its theoretical approach, without immediately redeeming them and putting them into practice. UMS

Gerhard Richter
S. mit Kind (S. with Child, work cat. 827-4) 1995
Oil on canvas 52 x 56 cm
Hamburger Kunsthalle

This cycle of eight pictures, 'S. mit Kind', was painted in 1995 as a link between representational and abstract work, with first one and then the other playing a dominant role. Richter took his own photographs of his young wife and the new baby and first painted photo-realistic images, and then smudged the paint with a paintbrush while it was still damp (this technique produced the blurred quality that is typical of Richter). Finally the motif was scraped, scratched and pushed around with palette-knives of different widths, sometimes pressing harder and sometimes more lightly. The fourth picture in the series, which is shown here, was completely painted over with reddish-blue paint and then scratched horizontally.

This Madonna motif, now taboo, deals with birth and life but – because of the attacks on the intact image – also with destruction and death. At an advanced age the painter devotes himself to young life, and discovers a conflict of feelings within himself. UMS

Markus Lüpertz b. 1941
Schwarz-Rot-Gold –
dithyrambisch (Black-Red-Gold –
dithyrambic) 1974
Gouache, chalk on wrapping-paper on
canvas 262 x 197.5 cm
Hamburger Kunsthalle

"Put a steel helmet" – says Markus
Lüpertz – "over any set of clothes,
and it will acquire a face without
your needing to paint it." Lüpertz
finds a personal way of monumen-
talizing and alienating. He shows
form without content. It is only the
viewer who can invent the content
or think it into the picture. The
title, in which Lüpertz identifies
the main colours in the picture,
suggests a political interpretation
(black, red and gold are the colours
of the German flag).

Lüpertz has been using the addi-
tional word 'dithyrambic' in his
titles since 1964: it signals his in-
tention of thoroughly renewing

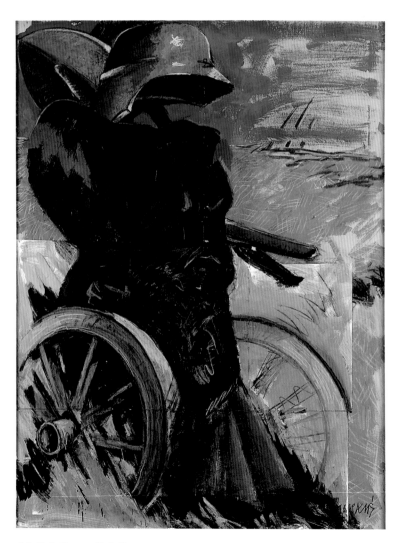

painting. The concept is borrowed from ancient poetry, where it relates to Bacchus's cultic hymn. The concept is associated with excess and a high emotional charge. Lüpertz explains himself: "Translated, dithyrambic means: drunkenly enthusiastic. I am drunkenly enthusiastic about myself and my painting . . ." DZ

Georg Baselitz b. 1932
Das große Pathos (Great Pathos)
1965
Oil on canvas 162.5 x 130.7 cm
Loan from a private collection in the Hamburger Kunsthalle

This painting is one of the 'Ralf' pictures, a group of works using Baselitz's friend, the artist A.R. Penck, as a theme and motif. Georg Baselitz shows Penck with a strikingly large ear. In 'Das große Pathos' the portrait seems to be bedded on a tattered flag. The body is indicated only by the arm, in which Penck is cradling a strange rodent. A toy-sized sack trolley and rake are added. The scene is reminiscent of a sleeping child, and its colouring is unusually tender for Baselitz as well. But Baselitz's title identifies the subliminal mood of the picture: 'pathos' means suffering in Greek. The flickering outline of the tattered flag and the bleeding red that occurs on the head as well, the threateningly large ear and the wide-open eyes suggest painful memories. This impression is additionally enhanced by the head, detached from the body and resting on a placeless flag, fluttering against a red and blue sky. DZ

Georg Baselitz
Bildelf (Picture-eleven) 1992
Oil on canvas 289 x 461 cm
Presented by the Freunde der
Hamburger Kunsthalle on the occasion
of the opening of the Contemporary
Art Wing in 1997

'Bildelf' is one of a series of large
pictures started in 1991 and num-
bered in order of composition.
Georg Baselitz intended the cycle
as a retrospective survey of his
early work, reflecting on his own
methods and techniques, motifs
and thematic groups.

This painting has a geometrical
ground of red and white fields
alternating as if on a chess-board.
This is overlaid with two figures
painted with black lines, which
Baselitz uses to relate to his 60s
'Helden' (Heroes) pictures. The
green bars on top of the figures are
borrowed from the 'Fraktur' (Frac-
ture) paintings of that period. Base-
litz put this canvas on the floor to
paint it. This relates to Jackson
Pollock's 'Drip-Paintings', but
unlike Pollock, Baselitz takes being-
in-the-picture literally: for 'Bildelf'
he climbed into a vat of green
paint while wearing his shoes, then
trod the four green bars on to the
canvas. He also painted the figure
without a brush, just using his
fingers. This technique relates to
his seventies pictures, which
include the word 'Fingermalerei'
(Finger-Painting) in the title. DZ

Gustav Kluge b. 1947
Zeugungsfalle (Breeding,
Procreation Trap) 1984
2 parts, oil on canvas
201 x 160.5 and 189 x 130.5 cm
Hamburger Kunsthalle

Gustav Kluge painted the 'Zeugungsfalle' pictures in parallel and in remorseless close-up. Here two cages have become just as much a unit as the two canvases of different sizes that make up the painting. There is an electric light-bulb in each of the cages, and one of the bulbs is under assault from a swarm of flies. The flies threaten the order established by mankind, which is symbolized by the cages: it is senseless to try to keep flies in a cage.

The title of the picture triggers metal associations. What is bred or created is a new and unexpected development that questions man's uncritical perception of himself as the measure of all things, and this perception becomes a trap if man is not prepared to accept his limitations. Places full of threats and alienation, the question of man and his place in the context of creation are the central themes of Kluge's pictures. DZ

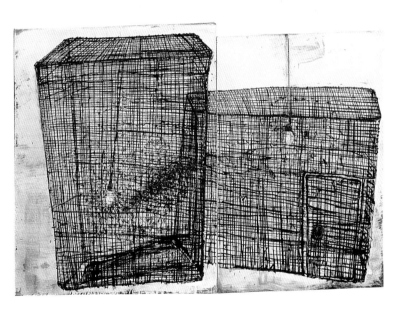

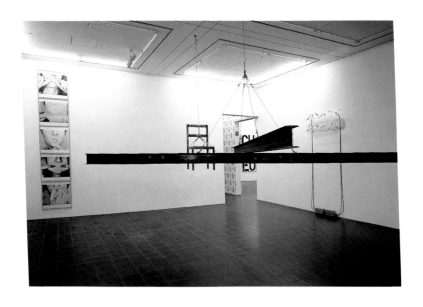

Media and Bodies –
New Art from America

Bruce Nauman has used a greater variety of materials for his work than almost any other artist: film, video, photographs, neon, metal, fabrics that can be shaped three-dimensionally, and not least his own body – the material is determined by the statement the work is intended to make. The viewer faces an onslaught of frantically changing or disturbingly still images, in which fundamental existential experiences are condensed. Nauman's undogmatic handling of material recurs in the pluralism of Americans who are in their forties or fifties today.

All the resources of Modernism are available to these artists, they seize upon the heroic achievements of the avant-garde, and work with them and against them: Marcel Duchamp's concept of the readymade, Andy Warhol's affirmative yet ironic treatment of the media and consumerism, or Minimal Art with its exclusion of hierarchies. But despite this borrowing, which cannot be overlooked, this generation's work is not just art about art. These artists constantly try to approach the social realities of their times. They are linked by their common experiences with the media, politics, sexuality and violence: in their youth the civil rights movement had shown them possible new ways of living together, and the booming eighties brought them back to the world of economic realities; they experienced liberalized attitudes to homosexuality, then saw discrimination against it start up again with the advent of Aids. Sexual stereotypes were resisted, broken down and then cemented again. This is the first generation to grow up in front of the television, but the Watergate scandal and what turned out to be false reporting from Vietnam made them realize that so-called media truth is a construct. Many of the artists represented here grew up in a middle-class atmosphere that they reflect in their work, commenting on its basic values when they ask: "How real is the reality conveyed to us by images?" CH

◁ **Bruce Nauman** b. 1941
Musical Chair 1983
Steel 86.4 x 487.7 x 510.5 cm
Froehlich Collection in the Hamburger Kunsthalle

In 1981, Bruce Nauman embarked upon a group of works in which he suspended chairs from the ceiling and surrounded them with different geometrical structures, as a means of coming to terms with reports of political persecution in South America. He chose the chair as a motif of isolation and torture. In 'Musical Chair' Nauman screwed

steel girders together in the shape of a cross and suspended them at eye-level. He suspended a steel chair from a second attachment point so that it hung within the cross of girders in such a way that it banged against the girders at the slightest movement and made a penetrating sound.

The title is not just a literal comment on the sound, but is also reminiscent of an earlier version in which Nauman tuned the chair-legs to the notes d – e – a – d. The title also refers to the children's game of 'musical chairs', in which players have to sit down when the music stops and the one who cannot find a seat is out. This threateningly forbidding sculpture addresses the experience of being oppressed and excluded.

MK

Bruce Nauman
Anthro/Socio (Rinde Spinning)
1992
12 video discs, 6 video-disc players, 6 monitors, 3 projectors
Hamburger Kunsthalle

The first works produced from 1990 onwards in Bruce Nauman's new studio in New Mexico were video installations with monitors placed one on top of the other in pairs, and wall projections. They show Nauman's face in extreme close-up, making word-like sounds to a fixed camera. In those works Nauman is the sole protagonist – as in his early video films – but in 'Anthro/Socio' he works with actor Rinde Eckert, who is also a trained singer. Eckert's head (sometimes upside-down) turns ceaselessly around its own axis on six monitors and three projection areas.

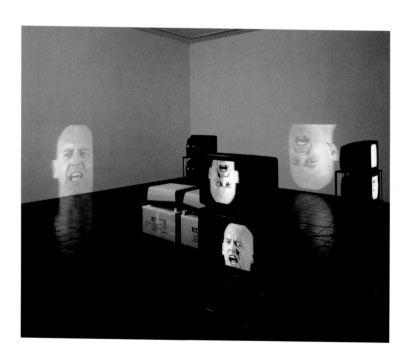

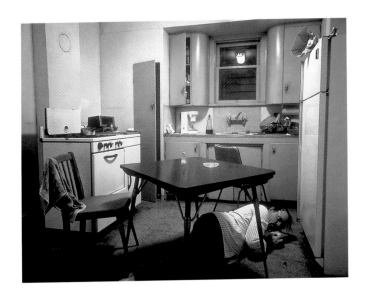

Eckert sings three different texts at various pitches, and they overlap like a litany. "Feed Me, Eat Me, Anthropology" and "Help Me, Hurt Me, Sociology" are similarly structured phrases in a logical series, while in the third text, "Feed Me, Help Me, Eat Me, Hurt Me", the opening sequences of the first two statements are mingled. Staged helplessness is transformed into a threat to the outside world. 'Anthro/Socio (Rinde Spinning)' featured at 'documenta 9' in Kassel in 1992. MK

Jeff Wall b. 1946
Insomnia 1994
Photograph, light box, Ex. 2
173.8 x 214 cm (photograph),
193 x 233.5 cm (light box)
Hamburger Kunsthalle

Jeff Wall's medium is photography. The Canadian artist has been showing large-format transparencies in light boxes since the late sixties.

His work may look like snapshots at first glance, but a second look shows that these pictorial worlds are complete constructs. Those involved and fragments of reality are always photographed separately and then put together using a digital process. Wall works with mask and costume designers so that he can alternately create disillusionment and a return to the spell, as in the cinema: "On the one hand, people know that it is only a film. On the other, the effects are so powerful that they forget this".

In the kitchen interior called 'Insomnia' a man who cannot sleep is lying on the floor. The cupboard and larder doors are open, and the paper bag on the refrigerator has been opened as well. Jeff Wall mixes a representation of sleeplessness with the traumatic experience of being unable to find one's bearings, which manifests itself in the strange position of the chairs. MK

Cindy Sherman b. 1954
Nr. 261 1992
Photograph 172 x 114.3 cm
F. C. Gundlach Collection in the
Hamburger Kunsthalle

Cindy Sherman works both as
director and performer. She does
not intend to present herself, but
slips into a role to show the
various stereotypes that exist for
viewing women. In the series
'Fashion', which was created in
1983/84, viewers are attracted by
strong colours and
a glossy surface.
They anticipate the
aesthetics of a
glossy magazine.
But Sherman the
model wears de-
signer fashion like
sackcloth and
ashes: the overlarge
knitted pullover is
not on straight, and
the decorations on
the cap hang down

over her face like limp feelers. The
eyes, red with crying, and the
swollen hand make a mockery of
any traditional fashion photograph.
Two trial shots in her lap make it
clear that the whole thing is staged
and at the same time address the
way in which Sherman creates her
images. BF

Nan Goldin b. 1953
The Ballad of Sexual Dependency
1993
Projection installation with
694 transparencies
Hamburger Kunsthalle

Nan Goldin opens up her visual
diary. A cross-faded slide show pre-
sents photographs of young peo-
ple – in shabby motel rooms and
smoky clubs, on the beach, in the
car, alone or in twos. The camera
shows us men and women who
have abandoned middle-class con-
ventions in their struggle to take
control of their own lives. They
carry the role imposed by gender
both as a burden and as a play-
ful pose. Their obsessive desire
for each other's bodies ex-
presses euphoria and depression,

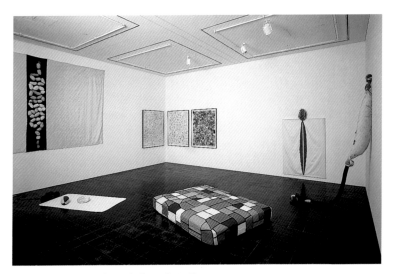

View of the room with works by Mike Kelley.

hunger for life and fear of death.

Goldin observes the power balance of autonomy and dependence in personal relationships in the 'family' that she has sought out for herself. She does not look with a voyeur's eye, she is a participant, and her photographs are snapshots and carefully staged at the same time: atmospherically dense, quaffably bright-coloured and eloquent to the last detail. The dramatic scheme is established with pieces of music of the kind that Goldin has always used to structure her work: pop music, Soul, old hits, with a Callas aria thrown in. The music provides a commentary on the photographs as they briefly appear and makes an uninhibited appeal to the emotions. A stream of images – as enlightening as it is unsparing – draws the viewer into the scene. Basic patterns in human relationships are revealed by focusing on New York bohemianism in the eighties. CH

far right in the picture
Mike Kelley b. 1954
E.T.'s Longneck, Two Brains, Penis + Scrotum 1989
Fabric animals found by the artist
330 x 26 x 26 cm
Scharpff Collection in the Hamburger Kunsthalle

The objects that Mike Kelley uses for his art are shabby and worn. His work combines the intellectual lucidity of Concept Art, which provided the context for his studies, with the gloomy anti-art of the American underground.

Kelley examines ordinary things and detects a metaphor of suppression and forgetting in childhood and puberty. 'Half a Man' is Mike Kelley's title for a group of works in which he uses fabric animals and crocheted dolls. In 'E.T.'s Longneck' harmless cuddly toys acquire sensual and compulsive life of their own. The ideas that adults have of childlike innocence are thus revealed as projections.

Cuteness becomes obscene, and beneath this seethes an uncontrollable imagination determined by sexuality and aggression. CH

Cady Noland b. 1956
Oozewald 1989
Screen print on aluminium, 2 pennants
182 x 59 cm
Scharpff Collection in the Hamburger Kunsthalle

Lee Harvey Oswald, accused of Kennedy's assassination, was shot dead on 24.11.1963. Oswald denied it to the last, and there are still doubts about his guilt today; but his murder in front of the cameras was a great show for the media.

The sculpture that Cady Noland devoted to this event is cool and acute, aggressive and fanciful at the same time. She has isolated the form of Oswald from the press photograph that went round the world at the time and printed it lar-

ger than life-size on a stamped-out aluminium sheet. With seven circular holes in the collapsing victim, she has literally gagged him, stuffing two small American flags into his mouth. 'Infotainment' is the word our age has produced for effective media dissemination of political events and human dramas. Cady Noland's aluminium sculpture translates this handling of other people's fates into a striking image: the historical moment becomes a toy for adults. CH

Barbara Kruger b. 1945
Untitled
(You can't drag your money into the grave with you) 1990
Screen print on vinyl 277 x 389 cm
Scharpff Collection in the Hamburger Kunsthalle

The American artist Barbara Kruger appropriates methods and strategies from advertising in her work. She works with texts and black-and-white photographs that she combines and enlarges to the format of an outdoor display advertisement. Her pictures are always *trouvailles* that she takes from advertising brochures, among other things, but she writes the texts herself. Barbara Kruger trained as a graphic designer, then started her artistic career in the late sixties. She often uses sayings that she breaks down into image or text, thus giving them a sobering twist that whisks the mask off power.

Black shoes are the hallmark of the businessman. The motif on Kruger's hoarding-size two-colour screen print could have been taken from a shoe brochure. She is questioning our culture-defining

drive towards increasing our wealth, and examines advertising – in its own terms – as a political medium.

MK

Robert Gober
b. 1954
Wedding Gown
1989
Silk satin, muslin, linen, tulle, steel
138 x 145 x 98 cm

Hanging Man/Sleeping Man 1989
Wallpaper Variable dimensions

Cat Litter 1996
8 parts, plaster cast, acrylic paint, Indian ink, pencil each 40.6 x 22.2 x 15.2 cm
All three works from the Scharpff Collection in the Hamburger Kunsthalle

A wedding-dress like an empty shell, sacks of cat litter and wallpaper whose gentle pastel shades are in stark contrast with its motif:

colour-pencil sketches of a sleeping white man and a lynched black man are repeated in an endless pattern.

Robert Gober has combined three individual works to make up a room that nevertheless resists an unambiguous reading. Instead of this it is open to viewers' associations and memories. But the intellectual associations are not random. The statement is limited by the motifs and the style of execution, charging the room, which seems homely at first, with the

View into the gallery with works by Jeff Koons

realities of racial hatred, fear and naivety. With the empty wedding-dress, which Gober tailored on his own body, stereotypical middle-class role allocations are questioned. Robert Gober's sculptures are the building blocks of an ideal middle-class world, behind which aggression and repression, self-deception and obsession become visible. CH

on the right in the picture
Jeff Koons b. 1955
Made in Heaven – Starring Jeff Koons and Cicciolina 1989
Offset lithography on paper on canvas
314.5 x 691 cm
Scharpff Collection in the Hamburger Kunsthalle

"Made in Heaven", promises the title of a film about an extraordi-

nary love affair, using a formulation that we more usually associate with the guaranteed quality of a product. This billboard-format poster was intended to advertise a film showing Koons and the Italian porn actress Ilona Staller, known as Cicciolina, in their most intimate moments, but the film was withdrawn before its launch. The two stars on their bronze rock are posing as the Adam and Eve of our times, with the serpent writhing beneath them. Koons bases the work on the sex films that made Ilona's name, but the actual subject is not sexuality. Art conquers sex, or better, absorbs it. The viewer is not seduced by eroticism, but by flawless execution. The audience that Koons is looking at is the actual subject. He comes to meets people as they look at these fami-

liar images from film and television: then they can find their way in all the more quickly, and each person can discover his or her own desires. Koons leads the way by liberating himself from guilt, fear and shame. BF

Christopher Wool b. 1955
Chameleon (P119) 1990
Gloss paint on aluminium
242 x 163 cm
Scharpff Collection in the Hamburger Kunsthalle

Christopher Wool placed stencilled letters on the smooth, white-painted ground of the aluminium sheet. The viewer is more prepared to perceive this typeface made up of individual areas as pure form than any other. The abstraction is further supported by the fact that the word is split up, not in terms of syllables but in relation to the borders of the picture. Thus the word is inserted as an articulating structure – as an ornament.

And yet words in a language with which we are familiar can never lose their referential character. In this way Wool addresses the poles between which painting moves: meaningless abstract ornaments and unambiguous messages that can be translated into words. CH

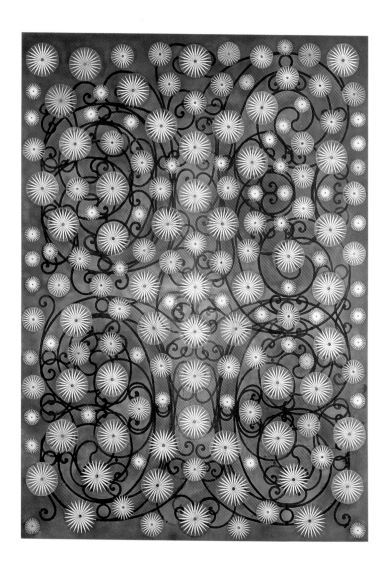

Philip Taaffe b. 1955
Constellation Elephanta 1993
Mixed techniques on canvas
353.7 x 254 cm
Scharpff Collection in the Hamburger
Kunsthalle

Philip Taaffe takes abstraction back
to its origins in ornament. He con-
fronts the path that abstract paint-
ing has taken in this century with
the desire for decorative enrich-

ment. 'Constellation Elephanta' is a
feast of colours and swirling lines –
and at the same time a subtle
game with one of the basic quali-
ties of ornament: axial symmetry.
At first glance the two halves of the
painting are reflected at the central
axis, but on closer inspection it is
possible to see how the strict
arrangement is constantly broken,
how the colours change in the
left- and right-hand halves of the

picture. and how the curling black bands develop without a precise pattern.

Taaffe's title, as he explains himself, refers to an island off Bombay that is known for important cave temples dedicated to the goddess Shiva; it also refers "to the notion of reflecting the character of a place of this kind through the position of the stars". Thus the title enlarges the scope of the painting by adding associations with a religious cult and with a cosmic order that stands above the laws of a symmetry created by man. CH

Terry Winters b. 1949
Tree-like Organizations 1995
Oil on muslin 220 x 300.4 cm
Scharpff Collection in the Hamburger Kunsthalle

Terry Winters uses traditional oil painting to represent contemporary technical structures. 'Tree-like Organizations' is based completely on grid structures. The entanglement becomes denser with every layer, until it is no longer possible to detect a starting-point. As in all his pictures, a brush-stroke does not express a spontaneous gesture for Winters, but indicates a calm movement, slowly carried out. Technical readings, like the lines on a radar screen, for example, are just as clearly present in the overlapping layers as cultic signs, for example a totem made up of trunk, sun and eye. The title of the picture, which Terry Winters perceives as a further layer of the pictorial entanglement, points equally to nature and technology: nature's branching tree structure is taken over in modern computer file managers in order to organize data. Natural structural building principles, archaic cultic forms and the high-tech present combine in a painterly synthesis. CH

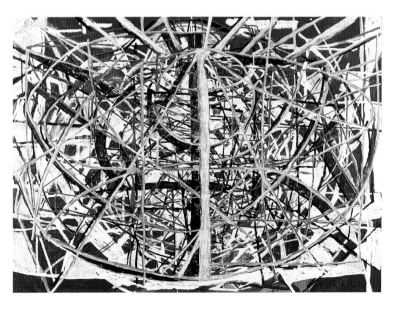

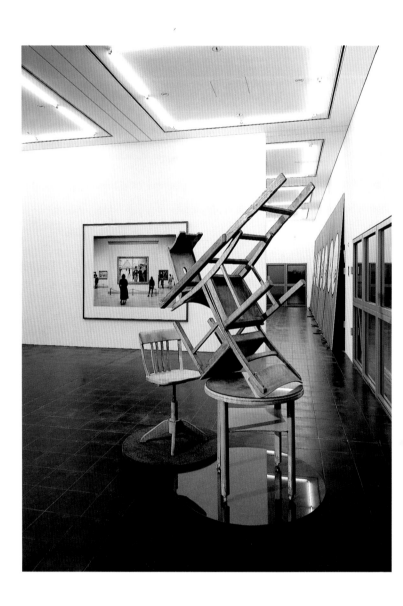

Recent German Sculpture

The concept of sculpture in the traditional sense of the Latin word 'sculpere' scarcely applies to work by young German artists at all, as they do not carve stone or wood. Nevertheless they are sculptors. They developed a number of possibilities for a new kind of sculpture in the eighties, through which they address the past.

All the variations have the use of easily recognizable objects in common. Standard products from the building trade, everyday objects and materials become art objects when placed in a new context. But they are not readymades as Marcel Duchamp would have understood the term: it is not just the aesthetic quality of the object that counts. The objects undergo transformations that do not simply release them from their functions but express the qualities inherent in them. Their original working context is part of the work of art. Material qualities are brought out, formal relationships discovered; things that have been found are combined with things that have been created, questioned by ambiguity and changes of scale; models and hypotheses are developed, linguistic metaphors are translated into visual terms through their original image, boundaries between art and everyday culture are blurred or ironically described, and doubt is cast upon them by alienation.

DZ

Reinhard Mucha b. 1950
Flak 1981
Furniture, glass, felt
211 x 190 x 100 cm
Hamburger Kunsthalle

Reinhard Mucha's work certainly has very little to do with traditional sculpture. But artists like Picasso were making everyday objects into sculpture even eighty years ago, because they felt that marble and bronze were antiquated artistic materials, trapped in the 19th century. Mucha has put old office furniture together so that its overall form is reminiscent of an anti-aircraft gun. It seems almost like a child's game until one realizes that the furniture dates from the time when the German army was employing this weapon, whose German name, Flugabwehrkanone, was abbreviated to Flak. Mucha found the furniture left behind in a room in Düsseldorf that he took over as his studio in 1981 – the year in which this sculpture was created. Thus the work, which seems to be based on a game, is at once a collection of evidence and an illustrated memory. Associations with weapons of war may have a martial ring, but the structure is extremely delicate. This anti-aircraft gun is more an image of the futility of war than an image of aggression.

UMS

Thomas Schütte b. 1954
Haus 3 (Haus für zwei Freunde)
(House 3 [House for two Friends])
1983
Wood, aluminium, lead
171 x 200 x 140 cm
Loan from a private collection

Thomas Schütte uses architects'
presentational resources for his
models of artists' houses, in which
he plays a large number of varia-
tions on communicative aspects
of artistic work. 'Haus 3 (Haus für
zwei Freunde)' is an atrium build-
ing made up of simple geometrical
forms, flanked by two outward-
facing towers. There are no win-
dows overlooking the middle of
the complex.

Disparate building types are link-
ed here. The impression of monu-
mentality created by the ratio of
window- to wall-area and the parts
of the building to each other is
very strange.

Schütte presents his houses on
tables that are an inseparable part
of the work. The table's green
colour is associated with tables
for games: Schütte is once more
pointing out the character of
models, and especially that free-
dom of action such playthings
both represent, and require in
order to find new building solu-
tions and thus situations in which it
is possible to communicate. DZ

Olaf Metzel b. 1952
Wurfeisen und Zwille [Entwurf
Hafenstraße] (Throwing-Iron and
Catapult [Hafenstrasse Design])
1990
Cast iron, steel, rubber
c. 147 x 200 x 500 cm
Hamburger Kunsthalle

*Thomas Schütte, 'Haus 3 (Haus für zwei Freunde)', 1983, above: 'Schwäbisch Hall',
1980*

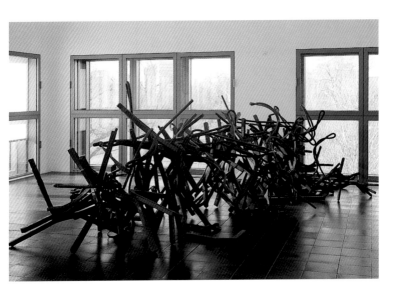

Olaf Metzel digs in his heels and creates barriers that block the view and the way. His work always relates to explosive contemporary issues. His sculpture 'Wurfeisen und Zwille' was a direct result of the conflict unleashed by squatting in some houses in Hamburg's Hafenstrasse. Metzel chose a significant detail when creating his image: the archaic projectiles used by the protesters. These weapons, made of material found by the squatters, were recast in iron and steel, and greatly enlarged. The lack of direction and bewildering number of elements in this barricade, which touches the ground in only a few places, reflects how frantic and brutal the riots were. Metzel creates a powerful image of the way in which clashes can become violent even under an effective parliamentary democracy. Without any moralizing undertones he angrily establishes that social peace still remains a Utopian idea.

BF

next page
Rosemarie Trockel b. 1952
Leopoldo I + II,
Maculata I + II 1993
Various Materials each 100 x 100 cm

Hund (Dog) 1994
6 parts, aluminium, paint
each 90 cm high, Ø 15 cm

Ohne Titel (Ofen)
(Untitled [Stove]) 1994
three parts, hotplates
each 70 x 70 cm

Ohne Titel (Untitled) 1996
2 parts, scannerchrome on canvas
each 120 x 120 cm

Ohne Titel (Untitled) 1994
3 parts, plaster Ø each 40 cm

Ohne Titel (Wollmuster)
(Untitled [Wool Pattern]) 1996
3 parts, screen print on perspex
each 60 x 60 cm

All: Hamburger Kunsthalle

Rosemarie Trockel shows motifs taken from private, female and domestic fields: here we have a dog, the domestic pet with whom

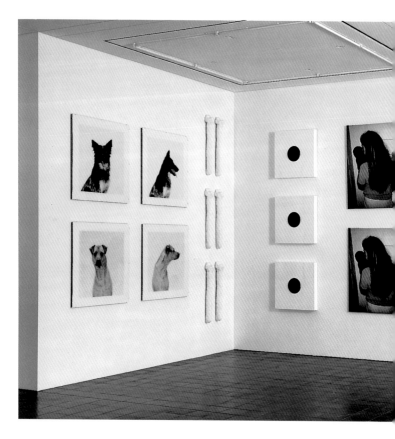

people like to bond emotionally. And as a faithful and attentive companion he is the model for the draught-excluders, possibly available only in hand-made versions, that we put at the bottom of our doors. We see hotplates, a woman in the home and home-made objects – in the form of knitting and of pottery, the epitome of a method of creative personality development favoured by women. Trockel is putting these and other connotations of being female up for debate here: domestic and non-public matters – conventions that are not normally addressed by art – or at least, not before Trockel embarked on her artistic career in the late seventies. She uses success-ful processes developed by her fellow artists to present her motifs wittily and cleverly, without feminist dogma. She doubled them and arranged them in series, she cast them, photographed them larger than life-size, packed them up in minimalist versions and put together six series of work on a corner to create an ensemble. MK

Andreas Slominski b. 1959
Fallen (Traps) 1989-1992
Various materials
Various sizes
Hamburger Kunsthalle

Andreas Slominski set ten traps. They lie in wait, endlessly quiet and patient, and yet tense. These

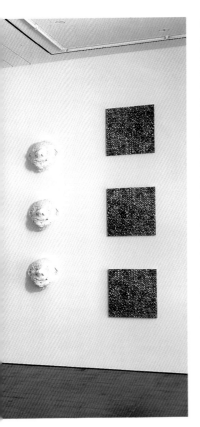

are animal traps from various periods and cultural backgrounds. But here in the museum the traps are not just waiting for the prey for which they were designed. They draw attention to the principles of setting traps. "Everyone sets traps", says Slominski. And at the same time everyone has to be careful about the traps set by other people, has to go through life with senses on the alert. This metaphor has a parallel in sayings like "setting a trap for someone", in other words pursuing them cunningly. The image derives from animal traps, but Slominski takes it literally and uses the original image to show a number of variations on the figurative sense. DZ

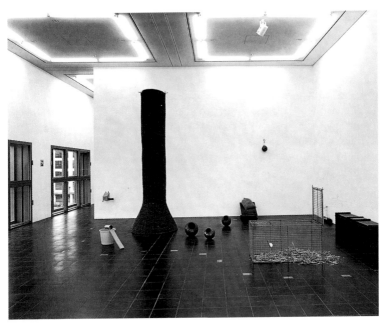

Objective Photography

'Der klare Blick' (The Clear Eye) was the title of an exhibition at the Munich Kunstverein in 1990, featuring Andreas Gursky and Axel Hütte among others. It could be taken as the motto of the artists in this section, who work with photography as a medium. Their work is driven by industrial photographers Bernd and Hilla Becher (b. 1931 and 1934) and their systematic series of work. As they neither arrange their subjects nor alter their prints technically they are known as objective photographers, in contrast to photographers like Jürgen Klauke and Urs Lüthi, for example. HH

Thomas Ruff b. 1958
Porträt (Anna Giese)
(Portrait ([Anna Giese]) 1989
Photograph 205 x 160 cm

Nacht 2 II (Night 2 II) 1992
Photograph 190 x 190 cm
Both: Hamburger Kunsthalle

Thomas Ruff adopts pictorial forms and technical resources from documentary photography in order to create new images. His 'portraits' are like outsize passport photographs. They are not of famous people, but average contemporaries of a generation and thus of a type in which the question of the relationship between facial features and character can be left out of account. His 'Night' pictures, which imitate photographs from the military and 'Science of Crime' fields, show that photographs can sometimes see more than the human eye. HH

Axel Hütte b. 1954
Castelfiorentino I and II 1992
2 photographs
each 237 x 187 cm
Hamburger Kunsthalle

Axel Hütte's photographs from Italy respond to the demands and aesthetics of painting, creating pictures in their own right from reality. His subject is the relationship between architecture and landscape. In his work every motif is both a copy and an element in the pictorial structure, as a result of the choice of viewpoint, the detail chosen and the atmosphere. This is particularly clear in the work done in Castelfiorentino, in which two details from the same building complement each other in terms of what they represent and at the same time identify the primacy of pictorial structure in the unity of the diptych. The 'objective' image seems to symbolize a mystery, in that a grille blocking the view, photographed in parallel in the two pictures, makes the landscape something that is just sensed as a perceptible presence, and secular architecture is made to seem diaphanous. HH

Andreas Gursky b. 1955
Schiphol 1994
Ex. 5/5, photograph
188 x 216 cm
Hamburger Kunsthalle

Andreas Gursky is drawn towards pictorial ideas in his search for motifs. He is not afraid to link his photographs with "remembered images", in other words with art-historical pictorial forms. However, he authenticates the images he carries in his head by means of readily intelligible, lucid, detailed renderings of what his eyes and camera see on the spot. This method of thinking and seeing allows him to create a pictorial order in which diversity also becomes a structural element, with the aid of details from landscapes and interiors, using carefully harmonized colours. Order as a

graphic link between culture and nature is the theme of his photographs of Amsterdam's Schiphol Airport. Modern architecture as a frame, as cold as it is classical, opens up a view of a man-made breadth of landscape, and then formally withdraws it. HH

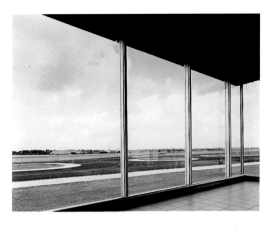

Candida Höfer b. 1944
Universität Amsterdam
(Amsterdam University) 1991
Photograph 36 x 52 cm
Hamburger Kunsthalle

Candida Höfer uses a relatively small format for her prints to emphasize that they are photographs, even when they are intended as pictures on a wall. These are not architectural photographs, not photographs in a specific subject field; she captures the characteristics of rooms that are easily viewed as a whole and filled with light. They are public places devoted to research, education or conservation in museums, with no people in them but steeped in tradition and convention. They are thus evidence of time, history and the social present. Höfer combines compelling composition with a strong sense of pictorial structure and order. And yet her photographer's eye also reveals the random, paradoxical and disturbing qualities of this order. Her images cannot be translated, they contain an inexplicable final element that invites reflection on photography as a medium as well as our own way of looking at things and our attitude as a viewer. HH

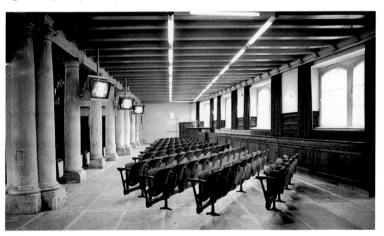

Thomas Struth b. 1954
Art Institute of Chicago II 1990
Ex. 9/10, photograph 184 x 219 cm
Hamburger Kunsthalle

Thomas Struth's 'Museum Photographs' are composed as individual works, but turn out differently in their contexts and contrasts. They stimulate us to compare museums, works of art and visitors' behaviour, and also to compare cultures and to observe cultural tourism. They make us think about the way in which pictures migrate and their place in museums, and at the same time open up temporal dimensions between the time when the pictures were painted, the time represented and the time when the photograph, which 'immortalizes' a moment, was taken. In the process, Struth, a painter with some experience of art history, takes works of art in museums very seriously, making the relationship between painting and photography, photography as painting, his subject in a double sense. This is conveyed by the viewers in the images, who refer us back to our own role as viewers and museum visitors.

Thus the museum becomes both photographed and experienced reality. HH

Installations II

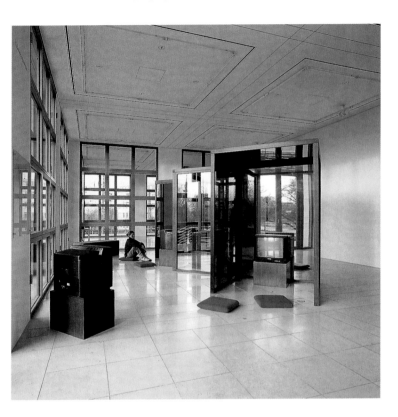

Dan Graham b. 1942
Three Linked Cubes /
Interior Design for Space
Showing Video Tapes 1986/87
9 parts, steel, glass, video installation
each 7 x 237 x 225 cm
Hamburger Kunsthalle

American artist Dan Graham has
been building glazed structures for
interior or exterior use since the
late seventies. They combine
architecture with sculpture and are
based on simple geometrical
forms.

If the work called 'Three Linked
Cubes', a set of booths with alter-
nating transparent and reflecting
glass panels, is set up in an interior,
it serves as a space for presenting
video works. The glass makes the
niches soundproof, but suspends
the architecture in a structure of
real and reflected spaces that can-
not be read immediately: the
video images are duplicated, and
on the walls, images are also
produced of visitors to other
booths, who, as they are behaving
in the same way, reflect our own
actions.

In this way Dan Graham has
reformulated the theme of his
earlier video installations using
surveillance techniques, and now
uses mirrors and light to feed the
viewers gaze straight back to
them. MK

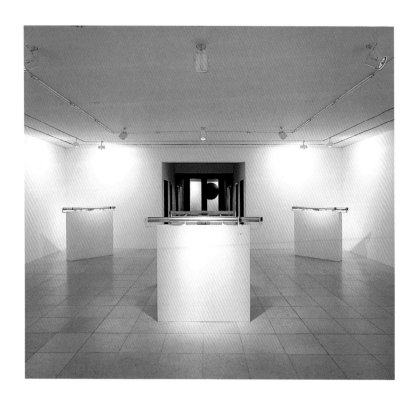

Stephan von Huene b. 1932
Text Tones 1982/83
6 parts, acoustic objects
each 138 x 138 cm
Hamburger Kunsthalle

Stephan von Huene's objects are
triggered by visitors' movements,
and record speech, footsteps and
other noises. A computer stores
the recorded material and plays it
back 45 seconds later as 'Text
Tones', changed by the acoustic of
the tubes. Two tubes are mounted
on six white boxes of equal size.
Between the tubes is an element
with just one tube. Its oscillations
determine the fundamental tone,
and the length of this tube deter-
mines the dimensions of the box.
The other tubes are longer or shor-
ter and produce tones that vary
correspondingly. They produce

sound most of the time, set
oscillating by their little hammers,
and they very seldom fall silent.
Stephan von Huene uses a com-
bination of acoustics, visual design
and interaction in many of his
works. This produces a new lan-
guage, without national or cultural
and historical barriers, and the visi-
tors themselves become part of
the work of art. TS

Bogomir Ecker b. 1950
Tropfsteinmaschine
(Dripstone Machine) 1996
Installation
Hamburger Kunsthalle

Bogomir Ecker researched and
experimented for over ten years so
that he could build a machine to
produce dripstone, the material

that makes up stalactites and stalagmites. But he was interested in the transformation process rather than the mechanics, in other words nature's original creative energies. He perceives nature as creative potential, as a showplace and reservoir for mysterious events that he has now shifted into the gallery. Rainwater is collected in the gutter and enriched with carbon dioxide and lime in a laurel-bush 'biotope' before dripping on to a marble slab in the machine room. Here time is seen as a historical dimension of the future. But the supposed art object, the dripstone, has still to develop. Five centimetres of growth are expected in five hundred years. Ecker illustrates his relationship with nature quite unobtrusively: it is not based on exploitation, but on a profound understanding of the whole – taking the attitude that it should be left in peace. DZ

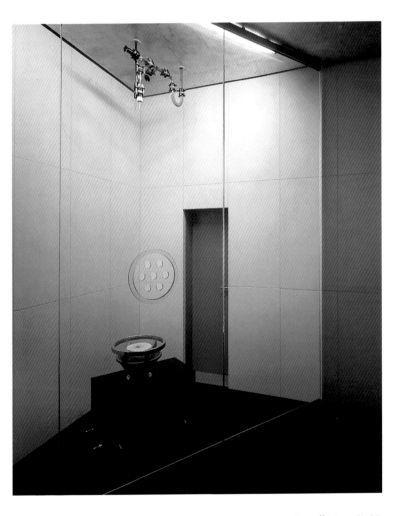

Index of Artists

© Hamburger Kunsthalle and Prestel Verlag, Munich · New York, 1997

© plans on inside cover: Peter Wehr, Hamburg

Edited by Uwe M. Schneede

German texts edited by Christoph Heinrich and Ortrud Westheider

Translated from the German by Michael Robinson, London
Copy-edited by Mike Green

Photographs: Elke Walford, Hamburg, except p. 6: Reimar Wulff and p. 41:
Olaf Pascheit

Authors of texts: p. 17

Cover photograph: Bruce Nauman, 'Anthro/Socio (Rinde Spinning)', 1992

Back cover photograph: Contemporary Art Wing, exterior (photograph:
Wolfgang Neeb)

Frontispiece: Light well in the Contemporary Art Wing, looking up
(photograph: Stefan Müller)

Prestel-Verlag
Mandlstrasse 26, D-80802 Munich
Tel.: + 49 89 381 709 0
Fax: + 49 89 381 709 35

Design: Verlagsservice G. Pfeifer, Germering
Typesetting: EDV-Fotosatz Huber, Germering
Printing and binding: Passavia Druckerei GmbH, Hutthurm
Repro: ReproLine GmbH, Munich

Printed in Germany
ISBN 3-7913-1899-3